REDCAR, MARSKE & SALTBURN

THROUGH TIME

Paul Chrystal
& Simon Crossley

AMBERLEY PUBLISHING

Acknowledgements

Thanks to the following for providing some of the photographs; without their generosity this book would not be what it is: Alan Musgrave and Jonathan Musgrave for the photographs of 'Dunkirk'; Neil Scarrow for the 'Optimists' photographs; Tony van de Bospoort at Hospital Art Studio, Pool and the League of Friends, Stead Hospital for the old and new photographs of the Stead Hospital on pages 29–31; Daniel Bramley; the staff of Kirkleatham Old Museum for the photographs on pages 53, 56 and 68; the staff of the Zetland Museum; the staff of Winkies Castle, Marske. Special thanks to Simon Crossley, who has managed and organised the images superbly, as usual.

Paul Chrystal and Mark Sunderland are authors of the following titles in the *Through Time* series published in 2010: *Knaresborough*; *North York Moors*; *Tadcaster*; *Villages Around York*; *Richmond & Swaledale*; *Northallerton*.

Paul Chrystal and Simon Crossley are authors of the following titles in the series, to be published in 2011: *Hartlepool*; *Vale of York*; *Harrogate*; *York: Industries & Business*; *York: Places of Learning*; *Towns and Villages Around York*; *Pocklington and Surrounding Villages*. Other books by Paul Chrystal include *A Children's History of Harrogate & Knaresborough*, (2010) and *An A–Z of Knaresborough History* (revised edition, 2011).

Unless acknowledged otherwise, all contemporary photography is by Paul Chrystal and subject to copyright. To see more of Simon Crossley's work, go to www.iconsoncanvas.com. To see more of Hospital Art Studio's projects, go to www.hospitalartstudio.co.uk.

For Jonathan, Andrew and Philip

First published 2011

Amberley Publishing
The Hill, Stroud
Gloucestershire, GL5 4EP

www.amberley-books.com

Copyright © Paul Chrystal & Simon Crossley, 2011

The right of Paul Chrystal & Simon Crossley to be identified as the Authors of this work has been asserted in accordance with the Copyrights, Designs and Patents Act 1988.

ISBN 978 1 4456 0460 2

British Library Cataloguing in Publication Data.
A catalogue record for this book is available from the British Library.

Typeset in 9.5pt on 12pt Celeste.
Typesetting by Amberley Publishing.
Printed in the UK.

Introduction

Next fishy Redcar, view Marske's sunny lands,
And sands beyond Pactolus' golden sands;
'Til shelvy Saltburn, clothed with seaweed green,
And giant Huntcliff close the pleasing scene.

If nothing else, these verses by the eccentric John Hall-Stevenson (1718–1785) of Skelton Castle – friend of Laurence Sterne and author of a bawdy sequel to his *Sentimental Journey* – more or less define the extent of this book and characterise much of its content: the associations with the sea and with fishing, (occasional) sunny days, extensive beaches and rocks, all with Huntcliff jutting out in the background. Through over ninety old photographs juxtaposed with their equivalents from 2011, *Redcar, Marske & Saltburn Through Time* provides a fascinating glimpse of life as it used to be in these three seaside towns and how it is today. In taking such a journey, it shows visitor and resident alike just what has changed and what has remained the same over the intervening years.

Travelling north to south, we start with the Gare and the lighthouse – indicators of the area's reliance on the sea, the River Tees and the steel industry. Moving on to Coatham, we see how far the rivalry with nearby Redcar shaped much of what went on in the last two centuries, particularly with regard to doomed piers, busy promenades and sand-swept streets. Arriving at Redcar, the importance of beach entertainment and other leisure facilities – two fine parks and Redcar races – in sustaining a reputation as a resort is clear. The town's historical dependence on fishing is still evident today, as is the vital lifeboat service provided along the coast, with tangible evidence still visible in the museum which houses the *Zetland*, Britain's oldest surviving lifeboat.

In 2006, Redcar had the good fortune to be chosen as the location for the Dunkirk evacuation scenes in the film of Ian McEwan's *Atonement*.

In a kind of double take, some of these scenes have been used here as modern pictures to exemplify Redcar's heritage as a popular seaside resort and at the same time underline its enduring ability to provide entertainment of one sort or another on its seafront.

The rich and intriguing history of Kirkleatham with its halls, 'hospital', mausoleum and museum are depicted and described next; we then move on to Marske and the hall there, Cliff House, and more lives associated with sea and industry. The final chapter takes in the fine Victorian seaside town of Saltburn – a highly photogenic realisation of one man's dream. The Ship Inn with its history of smuggling, the Cliff Tramway, the grand Zetland Hotel, more superb beaches and another ill-fated pier are all vividly illustrated with photography old and new.

Paul Chrystal, June 2011

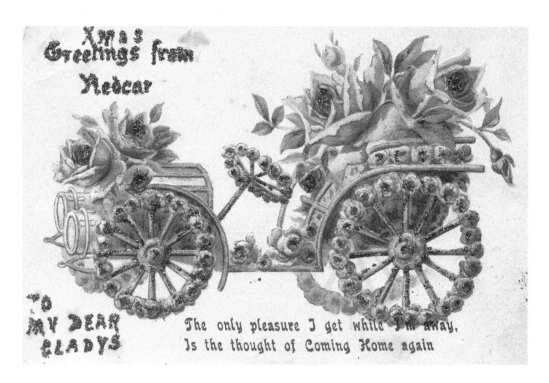

The romantic red car Redcar Christmas card is embossed and sprinkled with gold glitter – novel for the times; it dates from the early 1900s. The British Railways poster on page 5 by Dorothea Sharp in 1935 shows a familiar Redcar scene; the corresponding modern shot shows boats moored at Paddy's Hole on the Gare.

CHAPTER 1

Redcar

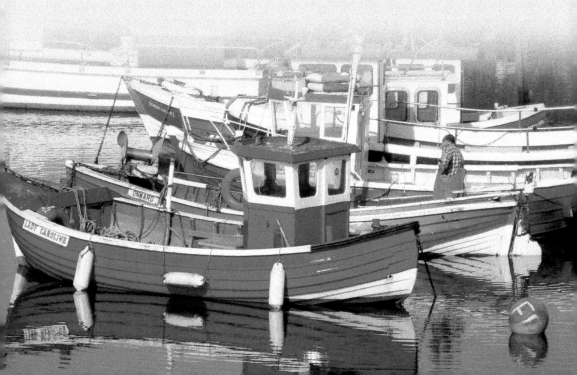

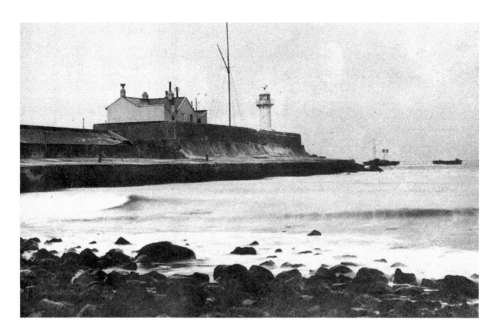

South Gare Breakwater

Building started on the 22 miles of walls that make up the South Gare in 1861 to provide a safe harbour and to allow the dredging of the sluggish waters of the Tees estuary so that ships serving the new iron and steel foundries could operate more efficiently. Blocks of solid blast furnace slag were positioned along the banks then backfilled using 70,000 tons of material dredged from the riverbed. This in effect canalised the estuary, allowing it to clean itself by the ebb and flow of the tides. Work on the Gare continued until 1884; by the end 5 million tonnes of blast furnace slag and 18,000 tonnes of cement had been used. The older photograph shows the Gare in about 1907.

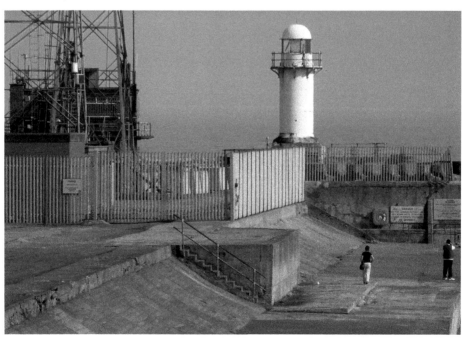

To the Lighthouse

The north end of the breakwater under the lighthouse is made from blocks of concrete weighing up to 300 tonnes. The 10-metre-high lighthouse, first lit in 1884, is a steel cylinder originally with a clockwork mechanism and a gas light – replaced by electricity in the 1960s – and manned by two lighthouse keepers who lived nearby on the Gare. Paddy's Hole (see page 5) was built as a mooring place in the breakwater for fishermen, which led to the rise of a village of fishermen's huts. From 2007 the lighthouse has been powered by a fuel cell. The old photograph shows well-dressed young ladies riding on the sail bogey on the Gare to see the lighthouse, birdlife and ships in the estuary. Sea fishing is more common these days.

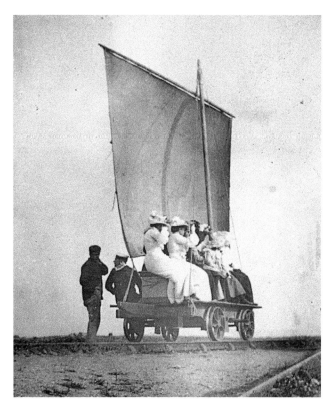

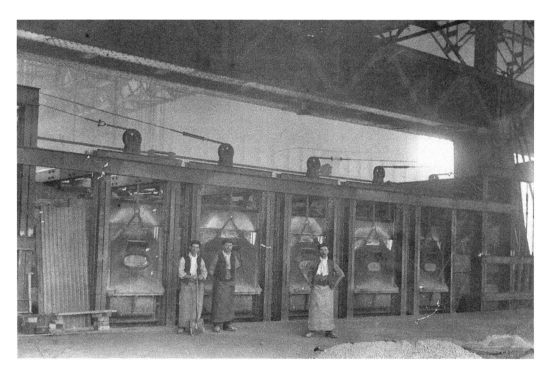

Dorman Long & Co.

The steelworks were built in 1916–17 after Dorman Long had taken over the old Warrenby Works and introduced new mixers, furnaces and plate mills. At its peak, the works employed over 5,000 men; to accommodate them, Redcar's 'Garden City' was built at Dormanstown. This photograph shows steelworkers in front of the open-hearth steel furnaces, contrasted with a modern shot of the works today.

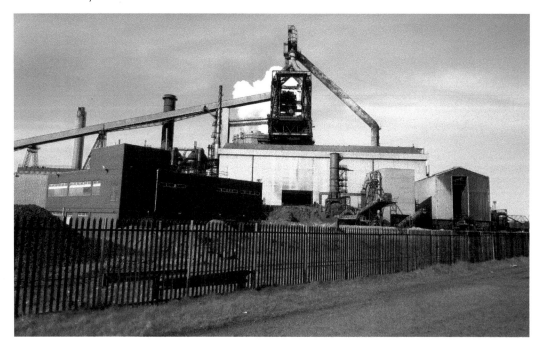

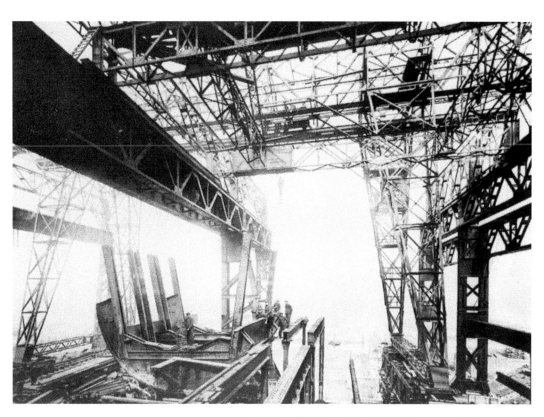

'Redcar Steel Deal is Done'
This is how in February 2011 Ian
Swales, Liberal Democrat MP for
Redcar, welcomed the news that a
deal had been struck safeguarding
700 existing jobs, with the possibility
of a further 800 at the Redcar plant.
The dramatic old picture shows the
steel plant under construction – an
open-hearth steel tilting furnace is on
the left with a 40-tonne Goliath crane
above. Steel produced here was used
to build the Sydney Harbour Bridge
in 1932, Newport Lifting Bridge in
Middlesbrough, Lambeth Bridge and
the Tyne Bridge, among many others.

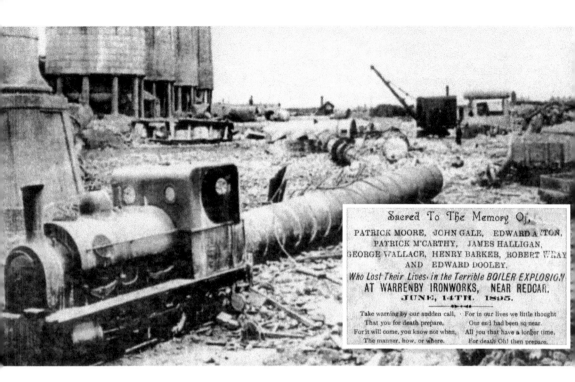

Sacred To The Memory Of,
PATRICK MOORE, JOHN GALE, EDWARD ALTON,
PATRICK M'CARTHY, JAMES HALLIGAN,
GEORGE WALLACE, HENRY BARKER, ROBERT WRAY
AND EDWARD DOOLEY.
Who Lost Their Lives, in the Terrible BOILER EXPLOSION
AT WARRENBY IRONWORKS, NEAR REDCAR.
JUNE, 14TH. 1895.

Take warning by our sudden call,	For in our lives we little thought
That you for death prepare,	Our end had been so near.
For it will come, you know not when,	All you that have a longer time,
The manner, how, or where.	For death Oh! then prepare.

The Warrenby Boiler Explosion

The horrific thirteen-boiler explosion at Walker, Maynard & Co.'s Redcar Ironworks in Warrenby occurred on 14 June 1895. Eleven workers lost their lives and eleven others were seriously injured. The disaster caused considerable hardship locally, which led to concerted efforts to make good the inadequate assistance provided by friendly societies – the only form of insurance available to most at the time. After a series of fundraising events, the fund was able to pay widows 2s 6d, orphans under ten 1s 6d, and orphans over ten and under fourteen 2s. The injured were similarly compensated. The new photograph shows a less tragic form of destruction, with cars flying out of a nearby scrapyard on Tod Point Road.

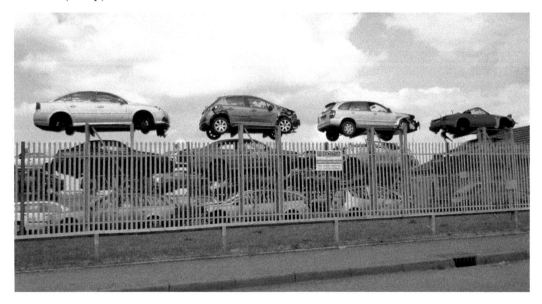

Whiting's the Tailor in Queen Street
Mr Charles Whiting, master tailor and
grandson of émigrés, returned from
Australia in 1902 and set up home and
business here at No. 17. At No. 23, J. Jowsey
was a 'Clothier, Hatter, Hosier and Gents'
Outfitter'. The railway line originally ran
down what was to become Queen Street
in 1861; the Central Railway Station was
built in 1845 in what later became the
Central Hall. Today, Mr Whiting's house is
occupied by the exotic takeaway pictured
here.

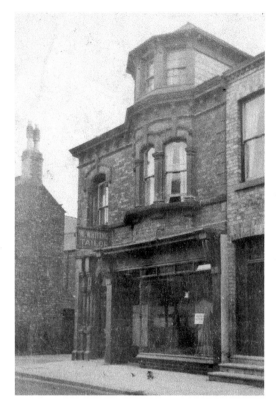

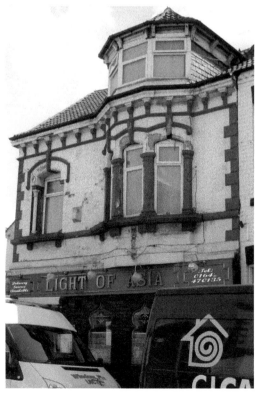

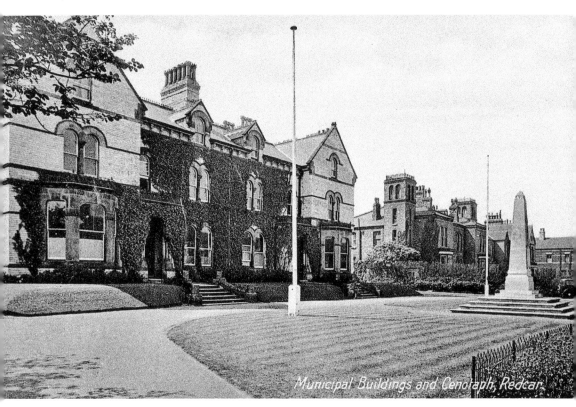

Municipal Buildings and Cenotaph, Redcar

Municipal Buildings and Cenotaph
Politically, Redcar Borough Council was the result of an amalgamation in 1922 of what were originally two fishing villages: Coatham and Redcar. This lasted until 1974, when it became part of Teesside Borough Council. The offices, originally formed from two houses – Seafield House and Norton House – were demolished in 1968. The Cenotaph was unveiled in 1926 by Viscount Lascelles, son-in-law of George V. The Newcomen family were heavily involved in the early development of Coatham: their influence can still be seen today, not least in the streets off Queen Street, each named after Arthur Henry Turner Newcomen.

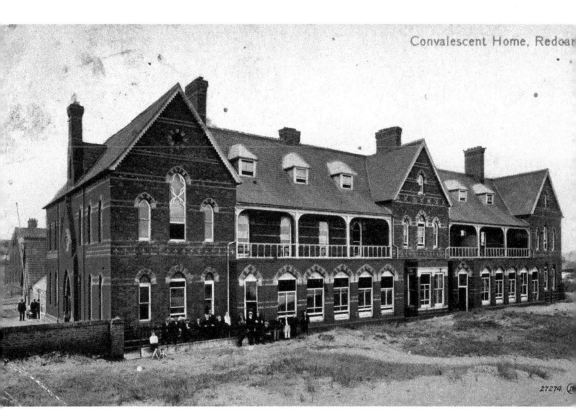

27274.

Coatham Convalescent Home, 1921
In 1861, Teresa Newcomen provided £4,500 for this institution and its 'poor and respectable' patients. Situated at the end of Queen Street, it was used mainly by subscribing (two guineas per month) mine, iron and steel companies for the convalescence of their employees after injury or illness. In the first year alone, the Sisters of the House of the Good Samaritan looked after 800 patients under the auspices of the first vicar of Coatham, the Revd John Postlethwaite; in 1881, a 250-seat chapel was opened. Soldiers were billeted there during the Second World War; it was demolished by Redcar Borough Council in 1951 to make way for the Redcar Bowl. The new photograph shows Rifleman Andrew Musgrave on the set of *Atonement*, awaiting evacuation from a spot near to where the home once stood.

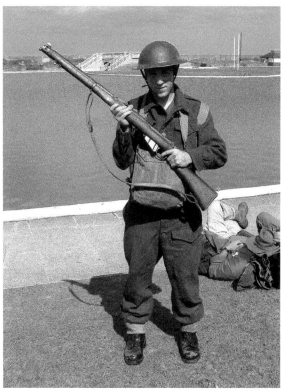

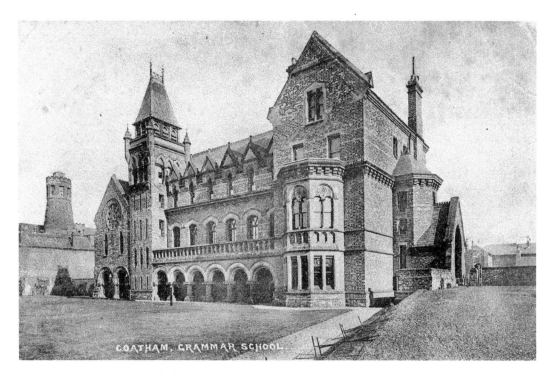

Sir William Turner's School

Or Coatham Grammar School. Turner made his pile from wool; he was Mayor of London in 1669, supervising the capital's rebuilding after the Great Fire. He died in 1692 and left £3,000 to pay for a free school in Coatham, which first materialised as the school building that now houses Kirkleatham Old Museum. This was vacated in 1869 when the grammar school pictured here was built; Redcar library now occupies the site after its demolition in the 1960s when the school moved to Corporation Road. Turner's name re-emerged in Sir William Turner's Sixth Form College in Redcar Lane; it lives on in the £3.94m Higher Education Centre at Redcar & Cleveland College nearby. The tower of Coatham windmill is to the left of the old school.

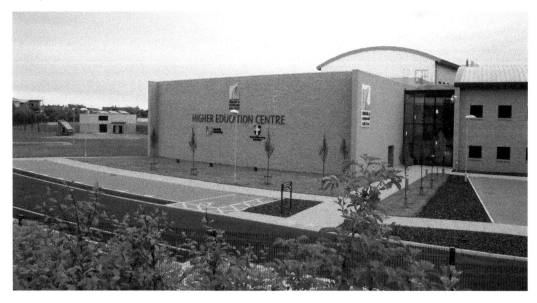

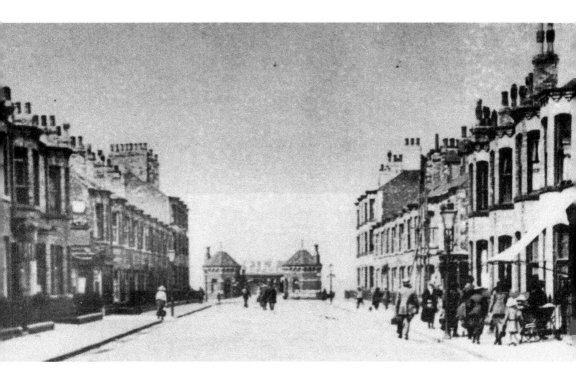

Station Road

The old photograph was taken from the junction of Milbank Terrace – named after Coatham windmill, which stood here – and Coatham Road. The original station, closed in 1861, was situated next to the Clock Tower in what became the Central Hall in 1873. The General Post Office occupied a large white gabled building in Station Road. Coatham Pier can be seen at the end of the road. Station Road, originally called Newcomen Street, was renamed in 1935. The modern shot is of Station Road today, with the Regent Cinema at the end where the pier once stood.

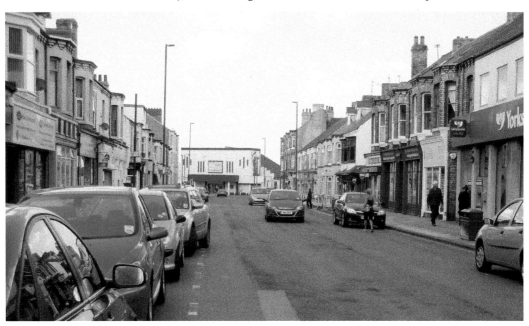

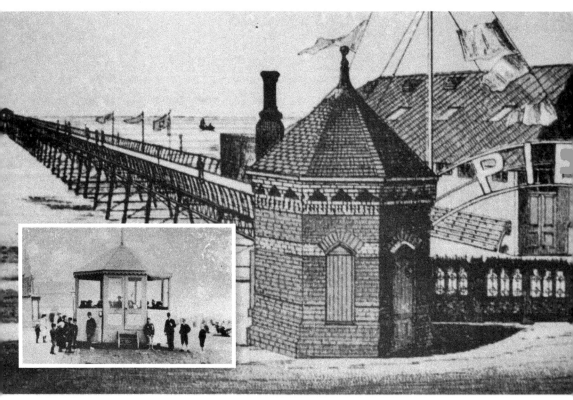

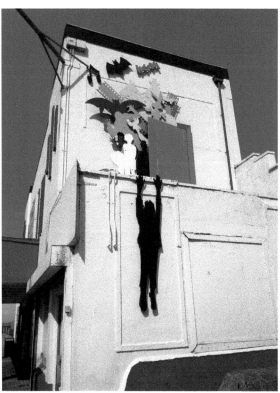

Coatham Pier

Finally completed in 1875, the pier was intended to extend over half a mile out to sea – 700 feet longer than the pier at Redcar; due to the cost of repairing it after damage caused by the brig *Griffin* and the schooner *Corrymbus*, which both collided with it during construction, the length of the pier was restricted to 1,800 feet. It featured a glass pavilion halfway along in which orchestras played – in contrast to the brass bands that performed along the coast at 'downmarket' Redcar. The inset shows the mobile bandstand that shuttled between Redcar and Coatham – the result of the two towns' inability to compromise on a shared facility. The new picture is of some interesting cinema-themed artwork on the side the Regent Cinema.

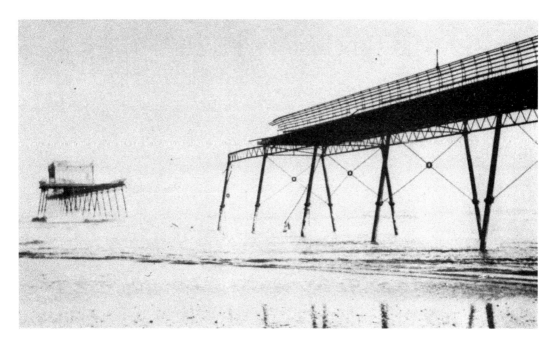

Breached by the *Birger*

In 1898 the barque *Birger* sailed straight through the pier, leaving the glass pavilion in splendid isolation out at sea. The captain and chief officer were both killed by the falling masts; only two out of a crew of fifteen survived. This disaster put the Pier Company out of business and brought about the end of the pier at Coatham. The new picture is of a Redcar lifeboat crew on a training exercise in their dinghy, ever ready to save lives along the coast.

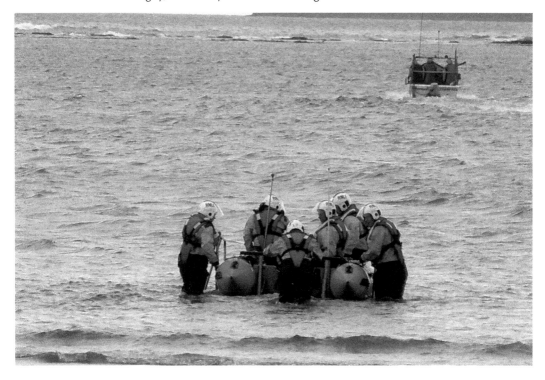

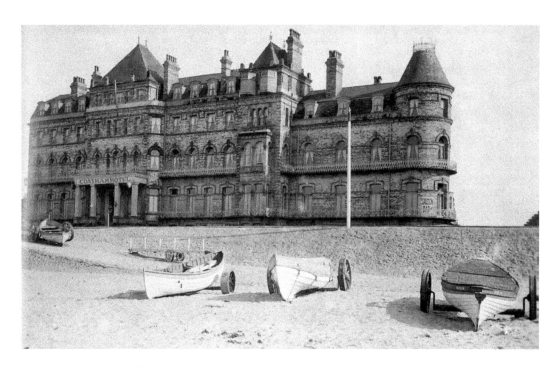

Coatham Hotel and *Alice in Wonderland*

Built in 1870, the east wing of this fine hotel was never completed as funds ran out during construction. The management company was Coatham Hotel Company Ltd, later Coatham Hydros Ltd: this name reflected the town's aspirations as a spa resort. Charles Dodgson – Lewis Carroll – stayed in nearby Granville Terrace and it seems likely that some aspects of the 'Walrus and the Carpenter' from *Alice in Wonderland* were inspired by the shifting sands here: 'They wept like anything to see / Such quantities of sand: / "If this were only cleared away," / They said, "it would be grand!"'

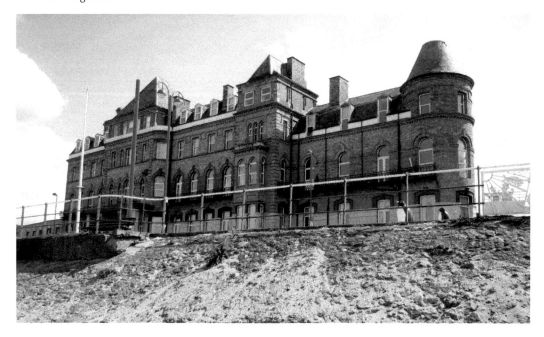

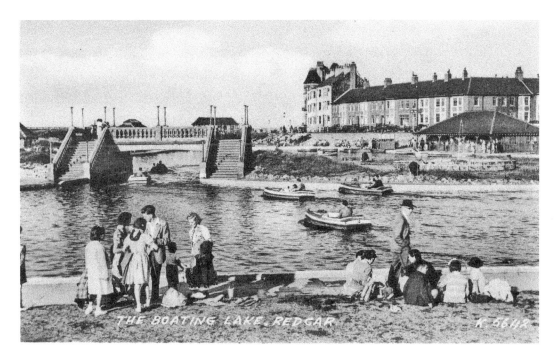

The Boating Lake

Part of the Coatham Enclosure opposite Arthur Street, the concrete-lined boating lake was built to a depth of 4 feet by unemployed labourers. The enclosure was developed by Redcar Council in the 1930s and was funded by the Government Development Aid Fund that was set up to help areas suffering badly during the Depression (see also page 49). The bridge leads over to the island with its pavilion, which would usually be festooned with flowers and illuminated in high season; the boathouse is the building at the top right; next to that was the nursery.

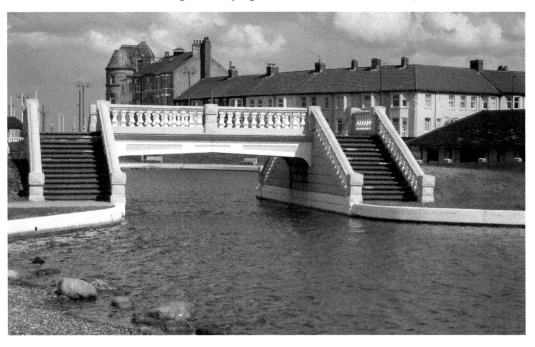

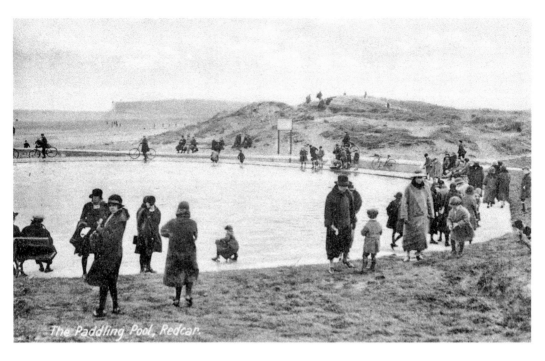

The Paddling Pool

This is now buried under the car park of the swimming baths. There was also a heated indoor swimming pool and a miniature golf course.

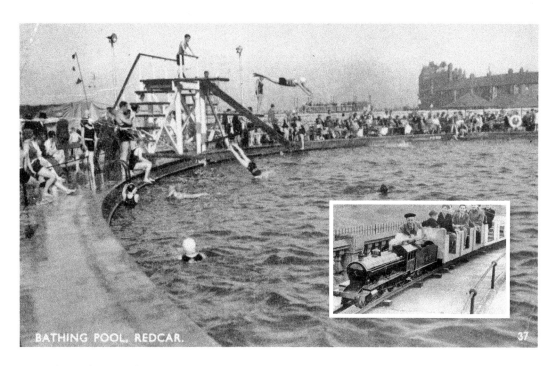

BATHING POOL, REDCAR.

The Bathing Pool, 1946

The circular swimming pool opened in 1930 and charged 4*d* for adults, 2*d* for children. Given the weather, it is hardly surprising that it was not a complete success and was covered over in the 1950s to be converted into the Rollerdrome, a roller-skating rink. A miniature railway operated round the perimeter; Gordon Trevitt was the driver around 1948.

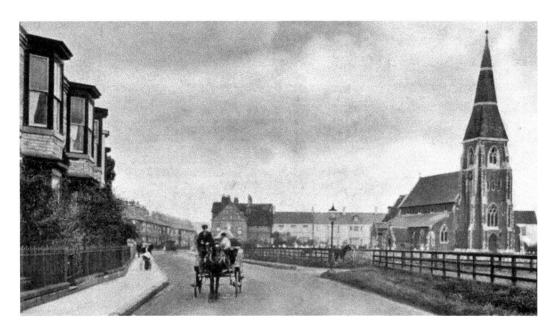

Coatham Road

Piers were not the only issue on which Coatham and Redcar were unwilling to compromise: high streets too were an intractable problem, with Coatham insisting on keeping its High Street, or High Street West, after the 1922 amalgamation. The photograph was taken around 1913 and shows Christ Church, Coatham, which was endowed by Teresa Newcomen in 1854; it was often called Church-in-the-Field because of its relatively isolated position, which was then in the middle of nowhere.

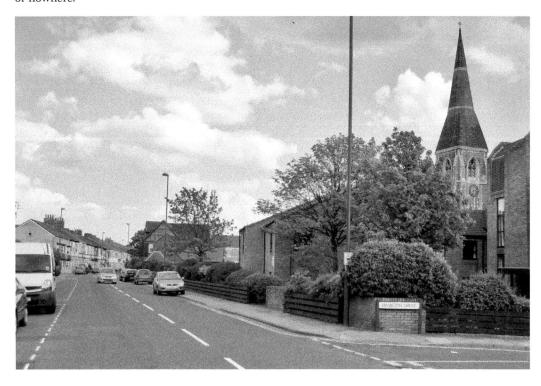

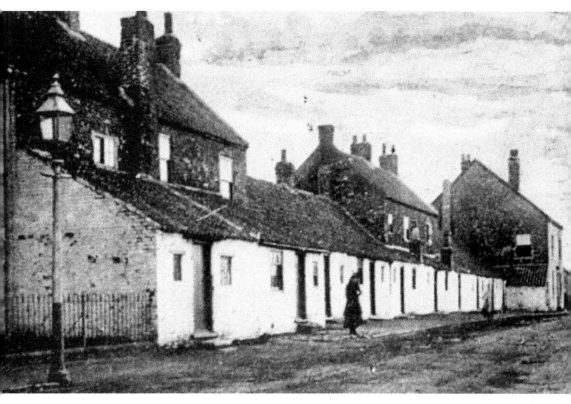

Old Coatham

A salmon fishery was established here in 1830. William Hutton's *Trip to Coatham at Eighty-Five*, published in 1810, describes 'Redcarre' as a 'poor fysher towne'; at the time both villages (still divided by a mile or so of green belt) comprised one street, with Redcar boasting 160 or so mainly mud-walled houses on both sides and Coatham 70 houses on one side of the street. Sand drifts were a major problem, and a hazard (see page 18). The arrival of the railway in 1841 boosted tourism considerably for both villages. The new picture shows the impressive Victorian plaque on James Terrace at the Coatham end of Queen Street.

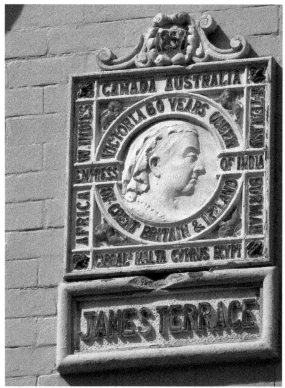

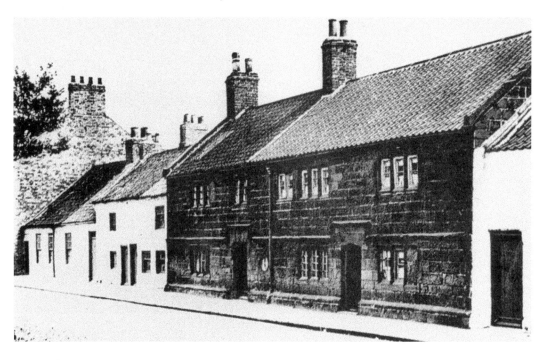

Yeoman's Cottage

On High Street West, this is probably the oldest surviving building in Redcar, dating from 1698. This date along with 'I. G. I', either the builder's or the owner's initials is inscribed above one of the doors.

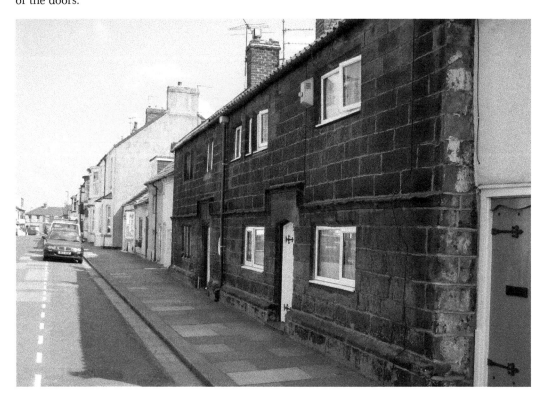

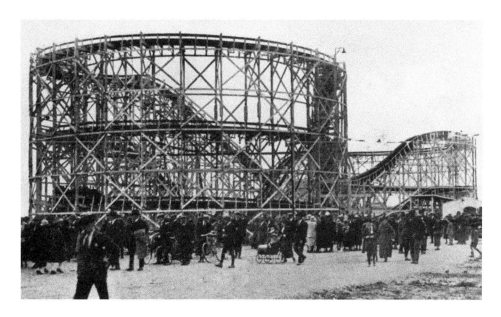

The 'Mad Mouse'

The Pleasure Park off West Dyke Road (now Buckingham Road and Sandringham Road) boasted the largest Giant Racer, Figure of Eight, or 'Mad Mouse' as it was known locally, outside London when it opened in 1925. Other popular features at the Pleasure Park included Noah's Ark Roundabout, the House of Fun in which there were crazy walks and distorting mirrors, the Giant Slide and the Tunnel of Love. Peg Leg Peggy was a one-legged stuntman who would dive into 4 feet of water from a 70-foot tower, but not before setting himself on fire. The modern picture shows Redcar reconstructed as Dunkirk for the filming of *Atonement* in 2006.

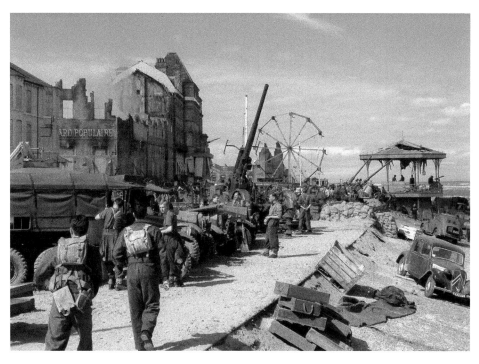

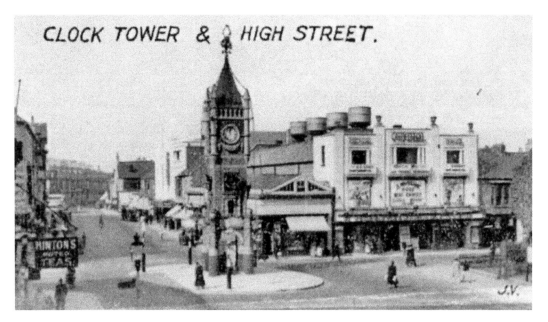

CLOCK TOWER & HIGH STREET.

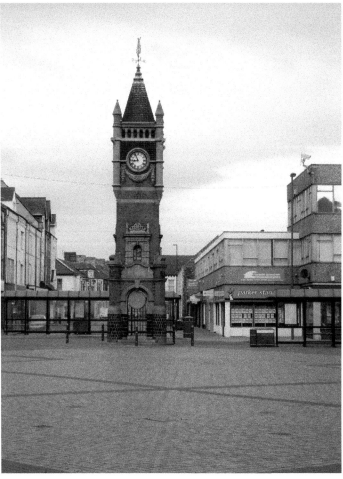

King Edward VII Clock Tower

Commissioned in 1913, the Grade II listed memorial clock was originally intended to commemorate Edward VII's accession to the throne, but not enough money could be raised by the public subscription. Ten years later, after the King's death, they tried again and succeeded in raising the required amount. The photograph depicts the Central Hall market with Central Cinema (*Anything Goes* starring Bing Cosby is showing) to the right; the latter building was destroyed in a 1940s fire but rebuilt in 1954. The landmark Hinton's sign is to the left and the Regent Dance Hall is behind the tower. Clock Tower apart, much of this view was swept away in the 1960s to make way for Craigton House.

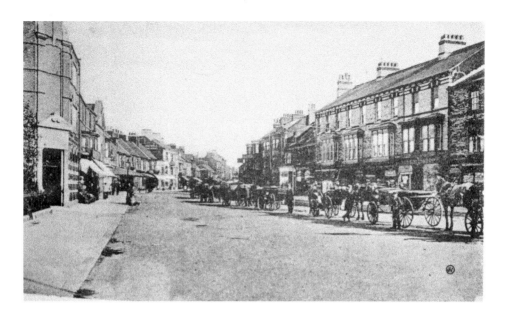

High Street

A shot from the entrance to Central Hall in 1907 showing the street with waiting horses and carriages. There are records of a fish market here in 1366. The first local market though was in Coatham, dating from 1257 when Marmaduke de Thweng obtained a King's Licence for a market and fair. In February 1922, the market was revived, with fifty stalls on the south side of the High Street, moving to West Dyke Road and closing in 1956. High-profile adverse publicity did little to help. Charles Dickens, on a brief visit in 1844, described Redcar and Coatham as 'a long cell' and apparently took one look before getting back on the train to Marske. Less temperamental visitors included Samuel Plimsoll (of Plimsoll Line fame) and novelist Nathaniel Hawthorne, who stayed in the Clarendon Hotel and then in lodgings. Today's photograph shows that there is still a place for horses on the High Street.

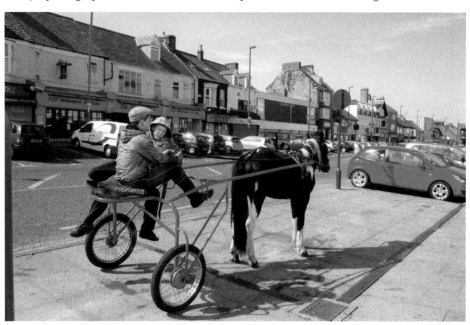

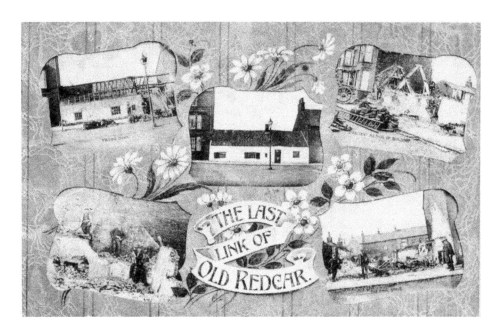

Pott's Cottage

This timber-framed cruck house was at 118 Redcar High Street. The nearby streetlamp played an important role in safety at sea: one of the panes was made of red glass and was aligned with a similar one on the Esplanade as a leading light to guide fisherman through Luff Way on West Scar. Demolition of the cottage in 1911 revealed a hidden cupboard behind the fireplace – a secret repository, no doubt for contraband. The card shows the stages of demolition of the cottage. The cottage may have gone, but some things never change, as the modern photograph, of gulls off the Redcar coast, clearly shows.

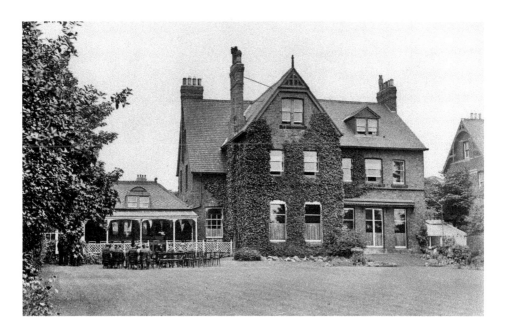

The Stead Memorial Hospital

The Stead (formerly Everdon Villa) was bequeathed to the people of Redcar by Dr M. F. Arnold Stead in 1929 for use as a seven-bed cottage hospital in honour of his late father, the metallurgist Dr John E. Stead who had specialised in the extraction of iron from its ore at Bolckow & Vaughan, the local ironworks. The Local Hospitals Charities Committee contributed £500 towards furnishings, £105 for 'an artificial sunlight installation', and £250 for upkeep in year one. For the first year the doctors of the town gave their services free of charge. Now that the hospital is closed, services have moved to the new Redcar Primary Care Hospital in West Dyke Road, where the Stead Hospital League of Friends and Hospital Art Studio have created this wonderful heritage mural to show visitors the history of the Stead Hospital, and in so doing have ensured that its memory lives on. The mural was entirely funded by the Stead Hospital League of Friends and the support they received from the local community.

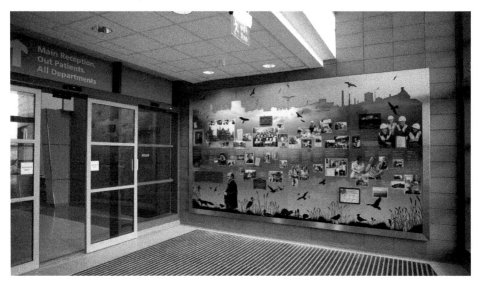

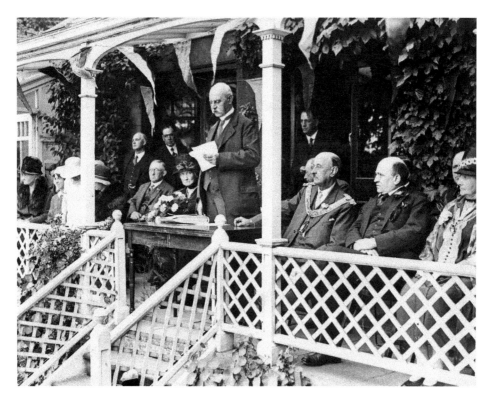

The Opening of the Stead, 1929

Alderman Hill, Mayor and Mayoress of Redcar, Dr and Mrs Stead, the Dowager Marchioness of Zetland and other local dignitaries are pictured at the opening of the hospital in July 1929. Dr Stead is speaking here. The closer view of the mural shows how skilfully the history of the Stead has been set in the context of the town's heritage: the steel industry and local wildlife form an impressive backdrop for intriguing details relating to the founding and development of the hospital. The photographs were provided courtesy of the League of Friends, and the display is copyright of Hospital Art Studio.

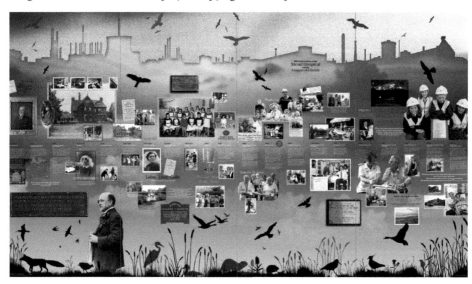

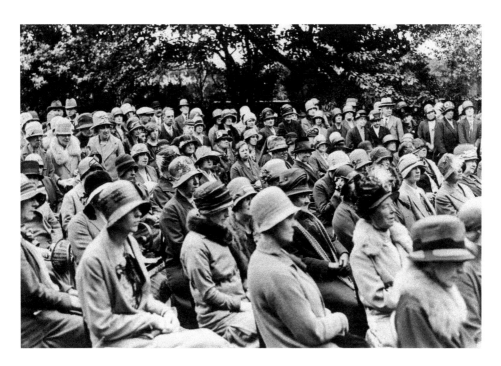

Hats Off to Dr Stead

This is the sight that would have greeted Lord Zetland as he stood up to address his audience. Nothing shows better the fashion of the time than old photographs such as these – hats were obviously *de rigueur* at such events. The newer photograph shows a group of Stead nurses on Christmas Day in the 1970s with young patients – note the presents, and the lollipop in the middle. Milly Sanderson was the first patient who, as a four-week-old baby, was admitted to have an extra toe removed; the operation was performed free of charge.

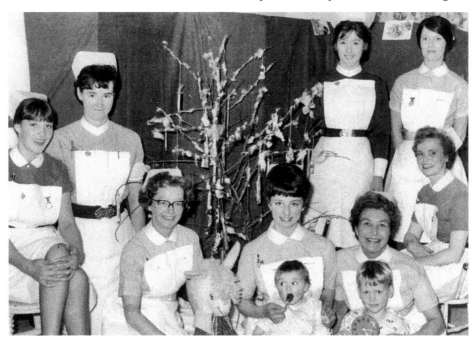

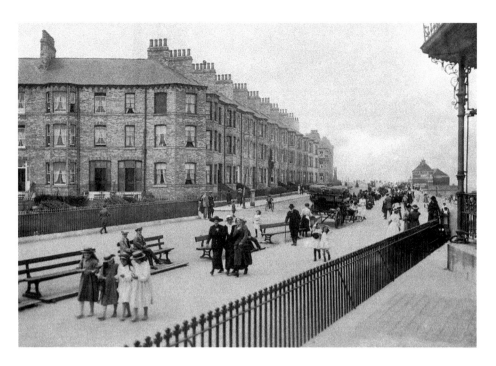

Promenade from Bandstand

This shows the junction of Newcomen Terrace and West Street in around 1918. Samuel Gordon provides us with an early description of Redcar in his *Watering Places of Cleveland* (1869): 'advantageous in an eminent degree as a marine resort ... in immediate proximity to the beach, is exposed to the full play of the bracing sea breezes, while at the same time it is so far removed from any of the great ironworks ... as to be entirely beyond the influence of their unsalutary effects.' Nothing much changed there then in the intervening 142 years, and, when it comes to arch rivals Redcar and Coatham, they were 'formerly separated from each other by green fields'.

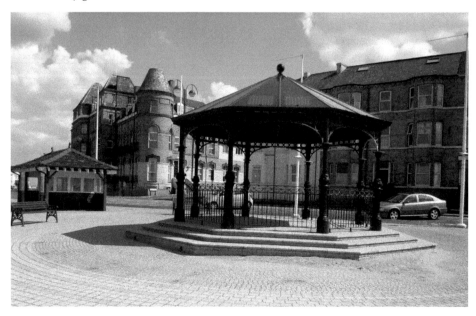

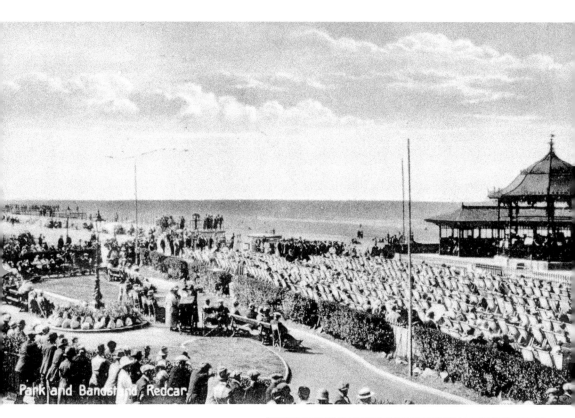

Park and Bandstand, Redcar

The Bandstand

This was built in 1905, at a cost of £400, to replace the mobile bandstand that plied between Coatham and Redcar. In 1910 it was extended to accommodate seating and public toilets, costing a further £1,000. Its popularity can be gauged by the number of deckchairs set out in front. Titty Bottle Park can be seen on the left – so named by a comedian Weary Willy because the park was popular with pram-pushing nannies. Each of the flower beds was dug in the shape of a heart, club, spade or diamond. The park was paved over after the Second World War and the bandstand was demolished in 1969.

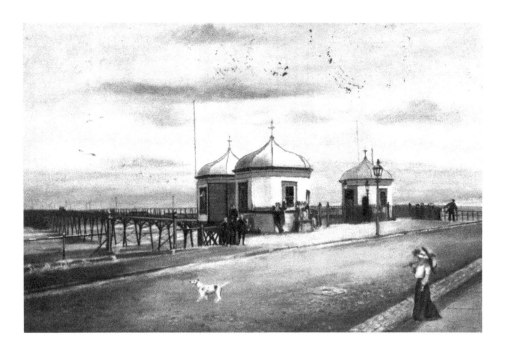

Redcar Pier, 1904

This was built by the Redcar Pier Company to provide 'a commodious promenade and landing pier' in 1871, largely in response to the construction of the rival pier in Coatham. It stood opposite Clarendon Street, extended to 1,300 feet and was 114 feet wide at the pier head. It featured sheltered seating for 700 people, a bandstand and a landing jetty for the Whitby to Middlesbrough pleasure steamers. The entrance featured the ticket kiosks shown here, a shop and rooms for ladies and gents. Damage from colliding ships, and the 1898 bandstand fire after a concert party, blighted its history; the Pier Pavilion dance hall was built in 1907. The pier was sold off for demolition in 1980 by Langbaurgh Borough Council for £250.

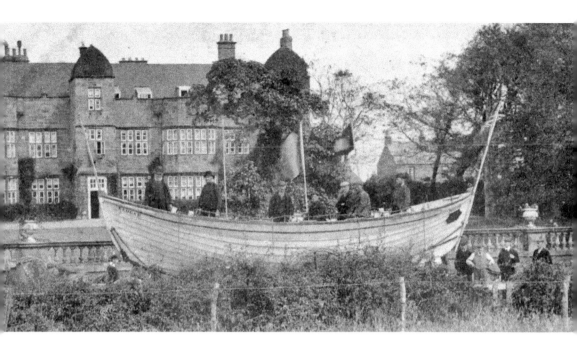

The World's Oldest Lifeboat

Built in South Shields by Henry Greathead, the eminent lifeboat designer, the *Zetland* is the world's oldest surviving lifeboat. Originally costing £100 and made from English oak, 30 feet long by 10 feet wide, she has an identical bow and stern so that she can be rowed in either direction. Crew comprised five oarsmen on each side and a steersman at either end. Copper buoyancy tanks replaced the original cork. From 1802 to 1880, she saved over 500 lives off Redcar and now takes pride of place in the Zetland Museum. The 1890 photograph shows the *Zetland* on display at the Marske Hall Leonard Cheshire Home.

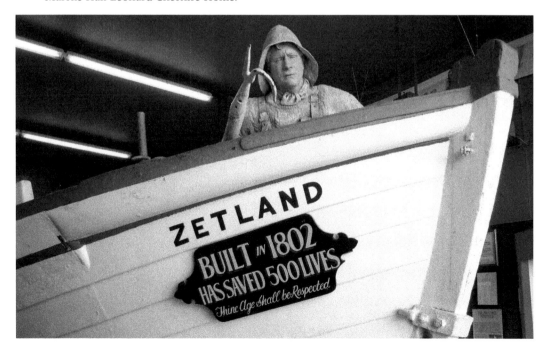

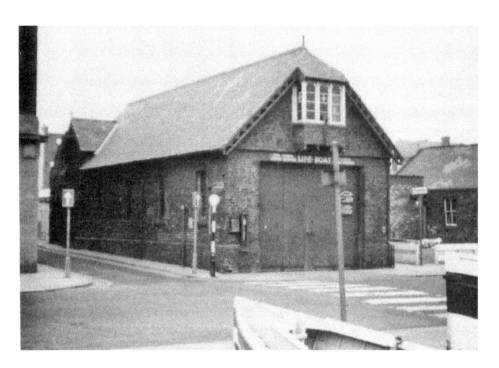

Redcar Lifeboat Station

The lifeboat was crewed by volunteer local fishermen who were summoned to their emergencies by a boy going round the streets banging a drum. The *Zetland* was decommissioned in 1880, but not before she had one last call after her two replacements were disabled when the brig *Luna* had crashed through Redcar Pier. Lifeboats were not Redcar's only weapon against the cruel sea: rockets too played a part and numerous lines were fired to ships in distress by this means. The headquarters of the Redcar Rocket Brigade was in what became Rocket Terrace.

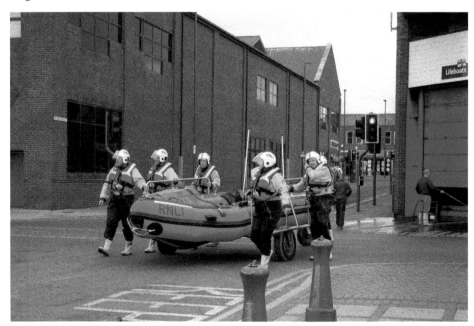

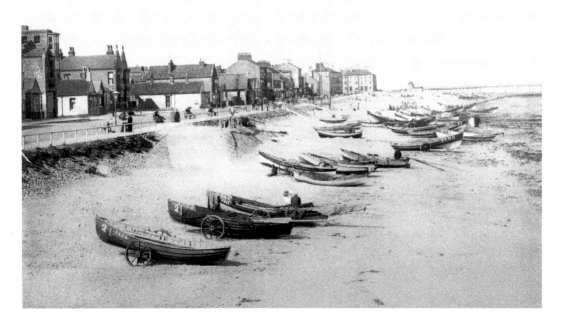

Redcar Boats

The *Zetland* is Redcar's most famous lifeboat but perhaps the most notorious was the Norwegian schooner *Amarant*, which in 1897 had been abandoned by its crew in heavy fog and was boarded by local fisherman as it floated aimlessly and dangerously between the two piers. After the cargo of timber had been salvaged, the boat was damaged in the ensuing storm and the hull smashed through Redcar Pier. All this after the *Luna* had crashed through the pier in 1880; the SS *Cochrane* followed suit in 1885. In 1898 the pier head burnt down. The old image shows the old lifeboat station to the extreme left (the Royal Hotel is out of shot to its right) – now the Zetland Museum. The remains of Coatham Pier – the kiosk – are visible on the mid-horizon. The pier may be long gone but the boats remain, as Rachael Jane Chrystal shows in the newer photograph.

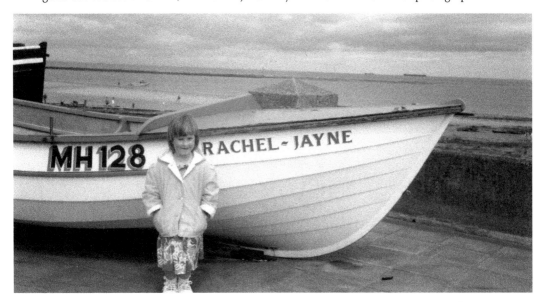

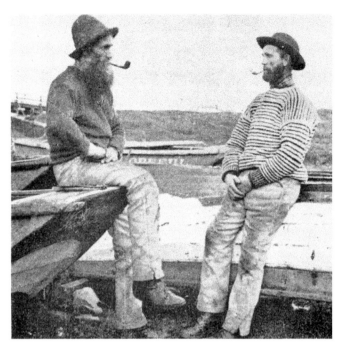

Redcar Fishermen
Taken in 1894, this photograph shows two fishermen, Bob Robson and Dick Watson, sitting on their boats; selling fish from a boat has been a regular sight on the beach for centuries and continues to this day. Smuggling too, of course, was rife here: in 1775 the revenue man for Coatham, John Ferry, received the following in a threatening letter: 'damn you and damn you Ferry and Parks, blast you Ise, you say you will Exchequer all of Redcar but if you do damn my Ise if we don't smash your Brains out ... keep off the sands or else.'

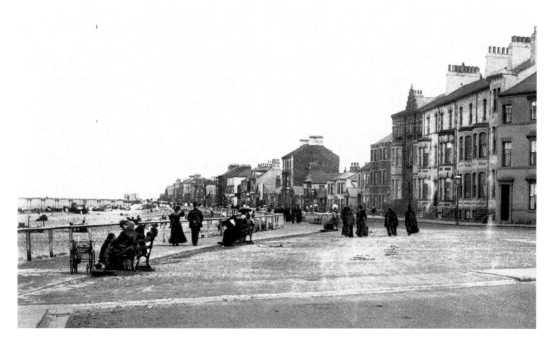

The Esplanade

By 1863, efforts were made to tidy up the town and rid it of the sand drifts blowing down the High Street and in the roads leading off it: 'The Spring cart of the farmer or tradesman and the chariot of the aristocrat now bowl along the street without the least impediment,' says Tweddel in his *Visitor's Handbook to Redcar, Coatham and Saltburn.* Redcar Pier was sectioned off during the Second World War as a precaution against possible invasion. This old photograph is from around 1918.

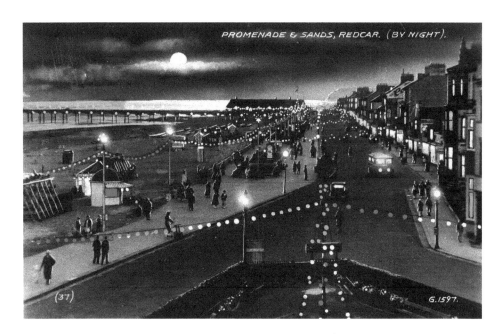

(37) G.1597.

The Promenade by Night

The 1930s saw the illumination of the Esplanade, Newcomen Terrace and the Coatham Enclosure where lanterns shone out from the flowerbeds and lights ran round the lakes. The island here was the focus of the display, with the sheltered seating transformed one year into a pagoda; the next year 'Welcome to Redcar' was beamed out. The Second World War brought an end to the lights, which were briefly restored in the 1950s along with an illuminated fountain on the island. In the 1770s, Sir Charles Turner brought bathing machines to Coatham to obviate the need to travel to Scarborough, where the contraptions were all the rage. Bath tents replaced the machines from the 1920s. The beach also hosted car and motorcycle racing in the 1930s as part of a course between South Gare and Saltburn. The 'new' photograph shows Redcar beach as 'Dunkirk' in a sunset scene from *Atonement*.

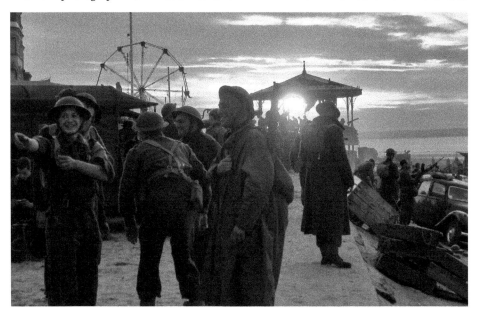

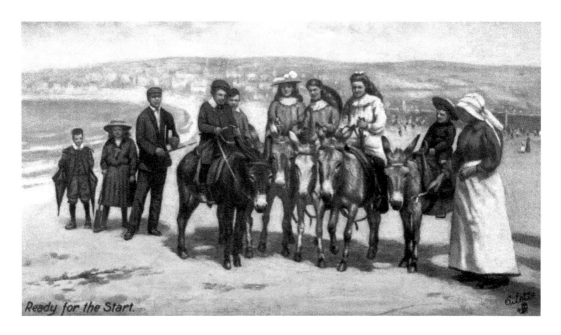

Ready for the Start.

Donkey Races

The flat and firm sands of the beach were ideal for horse racing and training, and so they were used until the opening of the racecourse in 1872. Like Hartlepool up the coast, Redcar had a brief flirtation with life as a spa resort – Dr Horner's Hydropathic Establishment was set up in 1850 on the Esplanade, where visitors could enjoy the delights of cold saltwater bathing and 'cure all ills'. Dr Horner ran a spa at 86 Nymphenburgerstrasse, Munich. Nearby Graffenberg Street was named after the then Silesian (now Czech) town of Graffenberg, where hydrotherapy treatment was pioneered by Vincenz Priessnitz in 1826.

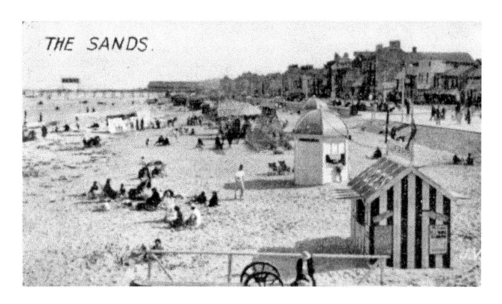

THE SANDS.

Uncle Tom's Sunshine Corner

Sunshine Corner was a popular attraction here from the 1920s; it was hosted by 'Uncle Tom' (with his concertina) who delivered a Christian message aimed mainly at children. They were invited on stage to recite a poem, read a short passage from the Bible or sing a hymn. The reward was a stick of Redcar rock. The 'Sunshine Corner Song' went as follows: 'Sunshine Corner oh it's jolly fine / It's for children under ninety-nine / All are welcome, seats are given free / Redcar's Sunshine Corner is the place for me.' Originally on the beach opposite the Royal Hotel, the stage set was once swept away, like a lot of things here, either by nature or by municipal vandalism; happily, in this case, it was rebuilt and continued to give pleasure until the 1950s. No Sunshine Corner for the troops awaiting evacuation from 'Dunkirk'.

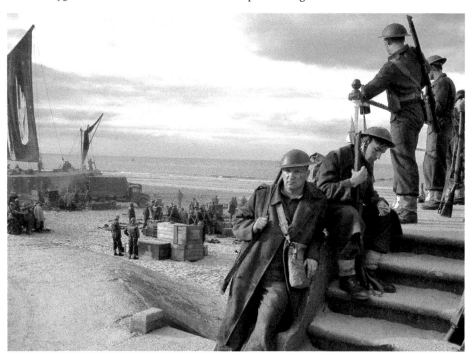

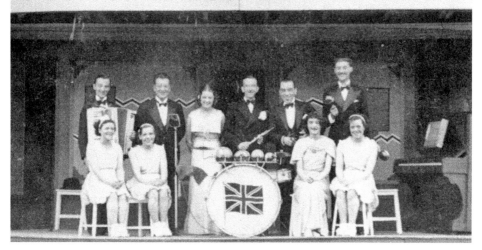

Billy Scarrow's Optimists

This was one of the many regular entertainments on the promenade and on the beach in the first half of the twentieth century. This photograph shows the Optimists' raised stage in 1937. The platform here had been raised by about 4 feet to offer a better view and avoid flooding at high tides. The Optimists performed here from 1918 to 1939, often giving three performances a day in the season, with Friday midnight shows (popular with landladies) in high summer.

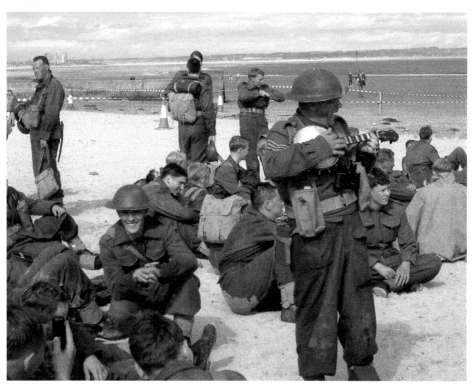

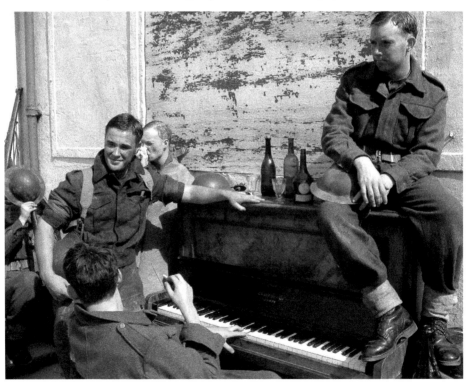

BILLY SCARROWS
OPTIMISTS OF 1936
7pm

Billy Scarrow and the *Skies of Spain*

The Optimists performed all manner of entertainments, including Pierrot shows, Lucky Numbers hosted by Mr Answers, and talent competitions for grown-ups and children. Billy Burden, later of television fame, was part of the troupe for a while. He went on to star in the *Harry Worth TV Show* and also made appearances in *Hi-de-Hi!* This and the previous modern shot show impromptu entertainment by British troops from the set of *Atonement*. The inset shows Billy Scarrow in a 1928 production of *Skies of Spain*.

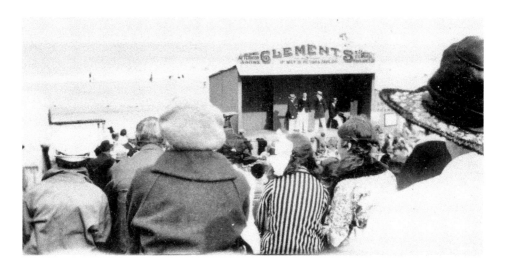

Clements on the Beach

Other turns included Willets White Stars in the 1920s, Professor Will Fleet's Punch and Judy, the many Pierrots in the early 1900s (the first of which was Johnny 'Smiler' Groves' Troupe), Professor Foster the ventriloquist, the Waddlers, Sam Paul and the Cleveland Cadets, Bert Grapho's Pierrots (the Jovial Jollies), Jackson's Merry Minstrels, and the highly controversial steam roundabout. Owners and guests of the guesthouses nearby complained of the noise from the roundabout to Lord Zetland, their landlord. He asked the council to remove it, but when the council refused on the grounds that the roundabout was a visitor attraction, he, as landlord to the council too, refused to renew its lease. This led to a summer of no beach entertainment and a disastrous season for the town, forcing the council to renegotiate the lease for the following season – with no steam roundabout to be seen, or heard. James McAvoy and Jonathan Musgrave star in the modern picture, on the set of *Atonement*.

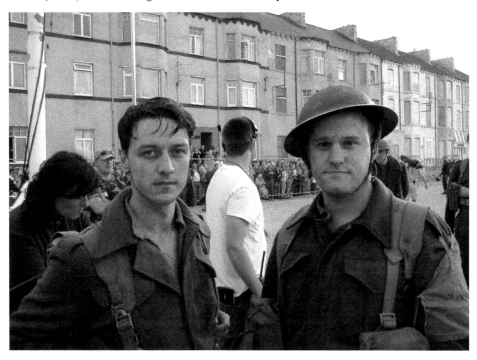

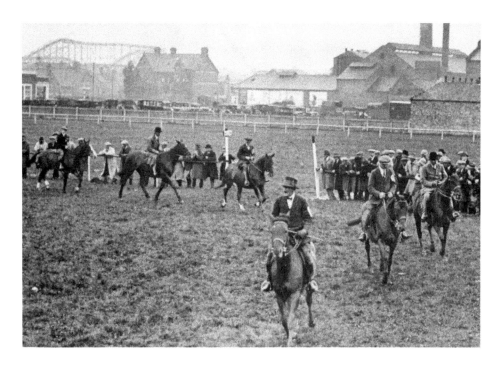

Redcar Racecourse

Racing was originally held on the beach, where a bathing machine served as the judges' box while the stewards sat on a farm wagon. The racecourse was regularly used by various regiments for training and camps; the Cleveland Agricultural Show also used it as a venue from 1833 up to 1966, when an outbreak of foot and mouth disease ruined that year's show, a crisis from which it never recovered. The 'Mad Mouse' and gas works can be seen in the background. The present course was laid in 1871 by the Redcar Race Company. Redcar has been responsible for a number of racing firsts: the timing clock visible to the public, furlong posts and colour CCTV. The new photograph was taken at a meeting in May 2011.

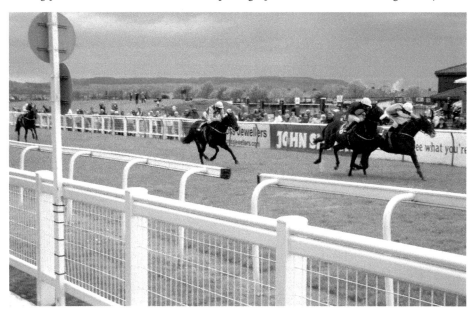

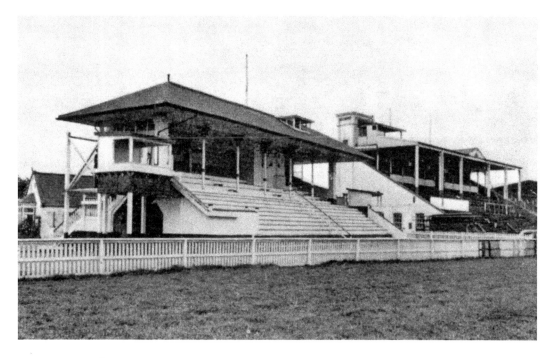

A Day at the Races

The first meeting at the racecourse was held in 1872 on land leased out by the Newcomens. The grandstand was built in 1875 and the course extended. The older picture shows the old stands, which were demolished in 1964 to make way for the £260,000 grandstand in 1965. Today's photograph shows the paddock behind the grandstand on the right.

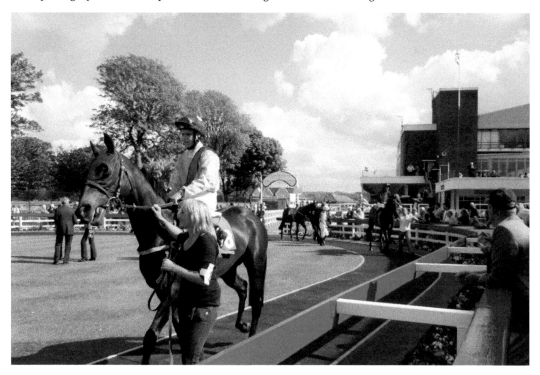

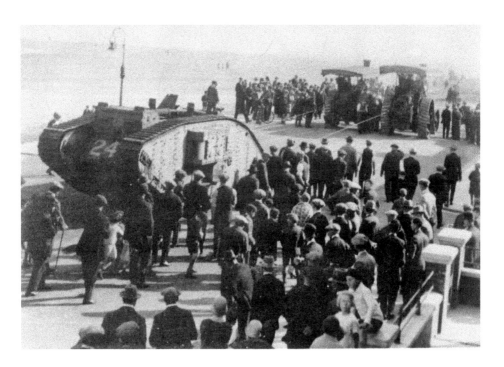

First World War Tank in Redcar

This First World War tank, No. 246, was presented to Redcar on 15 July 1919 in recognition of the town's efforts in raising money for the war effort. The tank arrived by train and was hauled through the town centre and displayed in various locations between the wars, finally settling near Zetland Park. In 1940 it was melted down for scrap and the proceeds were given to the Local Defence Volunteers. There is a plaque commemorating this on the gable wall of the garage at No. 1 Coast Road. The new photograph shows military vehicles on the set of *Atonement*.

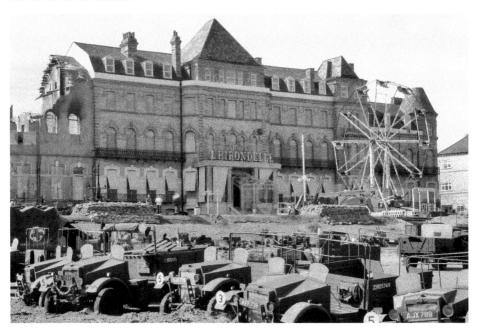

The Locke Memorial Park

Twenty acres of land here were left to the town by GP and JP Dr T. W. S. Locke on his death aged ninety-four in 1924, with instructions that a park be built on the land. This was done using workers who had become unemployed as a result of the General Strike. To further occupy these workers and keep them off the dole, it was decided to create a lake from the stream that runs through the park. The relief work continued through to 1928, when the park and lake were developed further with bridges, bowling greens, tennis courts and a putting green. More than 90 per cent of the costs of the park went on wages for these disadvantaged workers, making Redcar one of the first places in the UK to offer this type of council assistance. Other projects with the same arrangements included the building of roads to Dormanstown, Middlesbrough and Marske; Coatham Enclosure; sewerage systems; and new gas, water and electric mains. At the opening ceremony, the mayor's wife, Mrs Metcalfe, fell from her rowing boat into the lake.

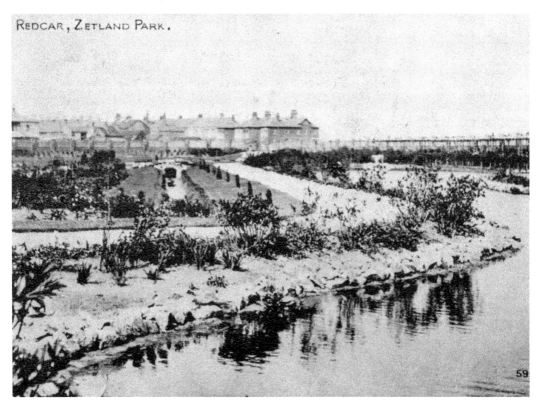

59

Zetland Park

Or Borough Park. The six acres here were given to the town by the Zetland family in 1923. The natural marshland was converted into a lake where a small promontory was the venue for brass band concerts. Bowling greens (still there) and tennis courts were popular attractions, as were the later aviary and mini golf course. The lake was drained and filled in during the 1970s. The rose walk can be seen at the north end of the park.

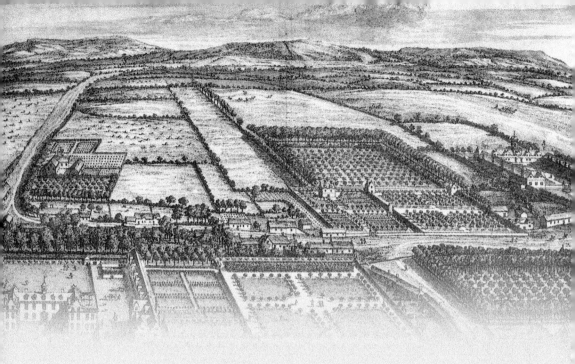

CHAPTER 2

Kirkleatham

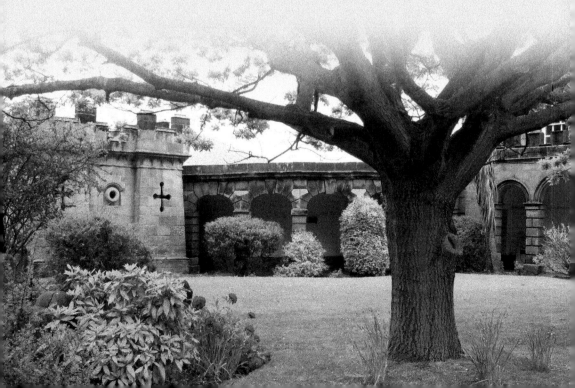

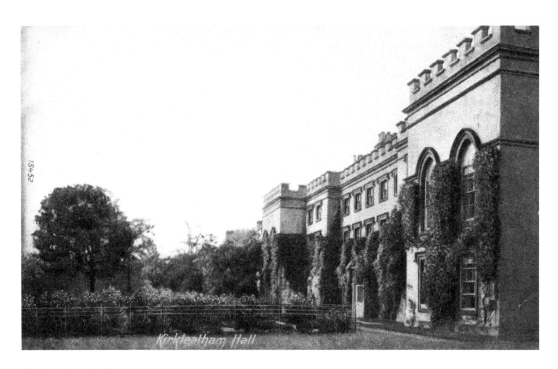

Kirkleatham Hall

Kirkleatham's Norse name was Westslide to distinguish it from Upelider, or Upleatham. Unlike Redcar and Coatham, Kirkleatham is mentioned in the *Domesday Book*; the surrounding lands were given to Robert de Brus by William I, and then to Thomas de Perci. Today's photograph shows the gates – complete with lions – of the hall with St Cuthbert's at the end of the driveway. Kirkleatham Hall Special School now occupies part of the site. The engraving on the previous page is *Panorama of Kirkleatham about 1700* by Leonard Knyff and Jan Kipp; it shows St Cuthbert's in the right foreground with the hospital behind.

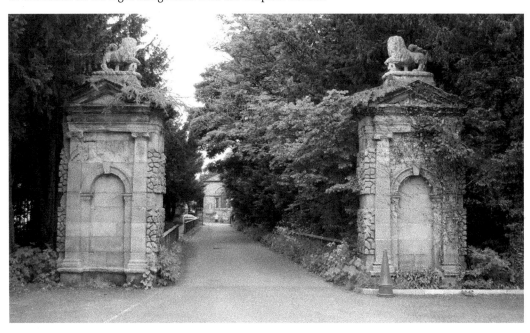

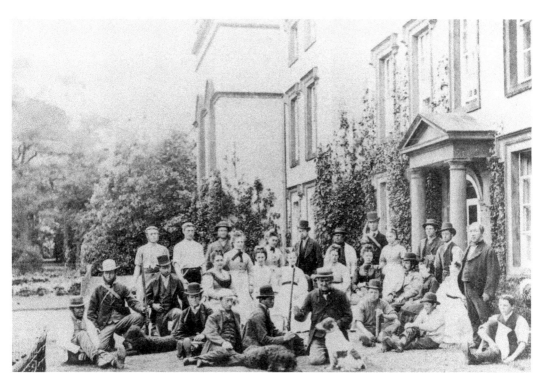

Mr and Mrs Henry Newcomen Turner at Home

The estate of Kirkleatham was bought by John Turner from the Billingham Bellasis family in 1623. At that time it covered Coatham and Dormanstown as well as Kirkleatham; the first hall was built in 1624 and rebuilt by Charles Turner around 1730. The old photograph is from 1874. In the 1850s, John Turner married Jane Pepys, a relative of Samuel Pepys; Turner's brother, William, became Master of the Merchant Taylor's Gild in London in 1660 and then Sherriff of London in 1663. The nineteen-bedroom Kirkleatham Hall was demolished in 1956 and replaced by Kirkleatham Special School. The new picture shows one of the vivid displays in the Kirkleatham Old Hall Museum showing seaside resort paraphernalia from Redcar, Marske and Saltburn. Photographs courtesy of Kirkleatham Museum.

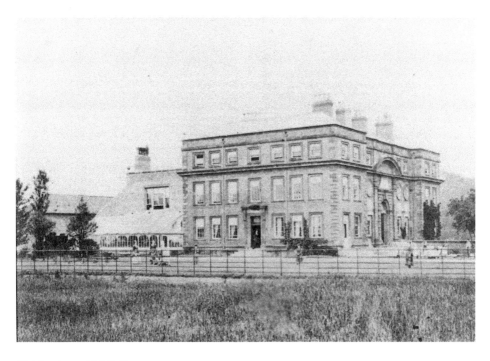

Kirkleatham Old Hall

Provided for in Sir William Turner's will, the Old Hall was established by Cholmley Turner as a Free School for the village in 1710; it enjoyed early success: half the pupils came from poorer backgrounds, yet forty students went up to Cambridge in its first eight years. The conversion into a museum started with Cholmley's son, Marwood, from 1738. Kirkleatham Old Hall Museum opened in 1981.

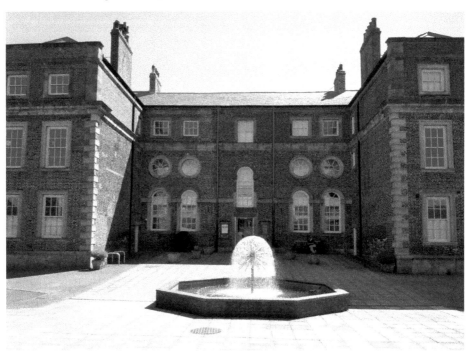

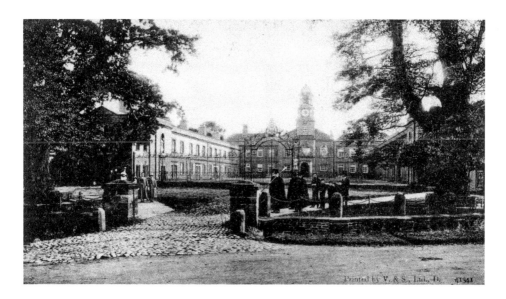

Sir William Turner's Hospital

Built by Sir William Turner in 1676 to provide homes for ten men and ten women of the parish who were aged over sixty-three. It also housed ten boys and girls – orphans or neglected children – from the village and provided their education up to 1946 here, and then later in the purpose-built school, now Kirkleatham Old Museum. Men lived in the west wing, women in the east, as indicated by the striking statues. Inside the chapel is a one-handed clock and the original charter with the seal of Charles II. During renovations in 1820 mini castles and bastions were added for decoration, although they did take on a practical purpose when they were converted into a laundry and storerooms. Today the hospital still provides homes for ten deserving men and women.

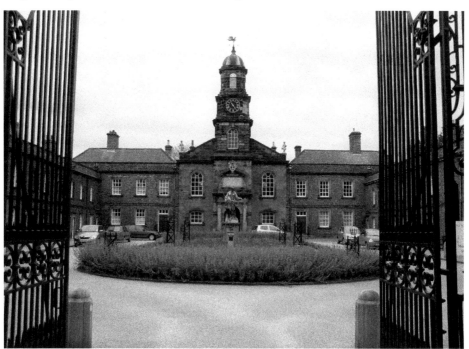

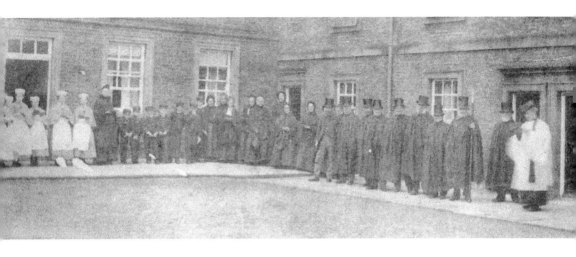

Hospital Residents, *c.* 1880

Records were kept of all residents; one of the more interesting documents tells us about the demise of William Jourdison, who died, aged eighty-nine, in April 1759 'of a Mortification in his leg, he lived three days after his foot fell off, and though in his perfect senses never found out the loss of it, till an hour before his Death'. Discipline was important and transgressions could lead to expulsion: 'July 20 1770 William Metcalf ... was expelled ... on a charge of Sodomy; July 23 1773 Jos. Russell ... expelled for disorderly living ... he was found one morning by the Governor excessive Drunk'. Photograph courtesy of Kirkleatham Museum.

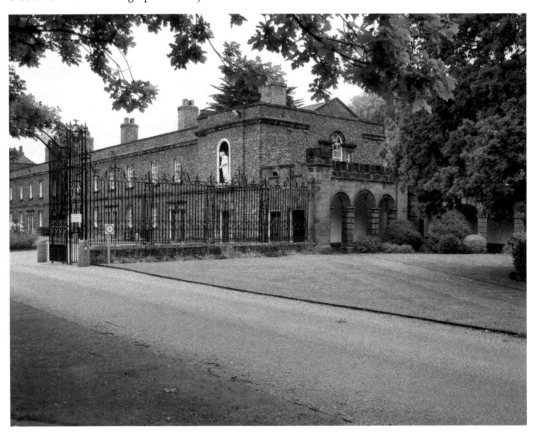

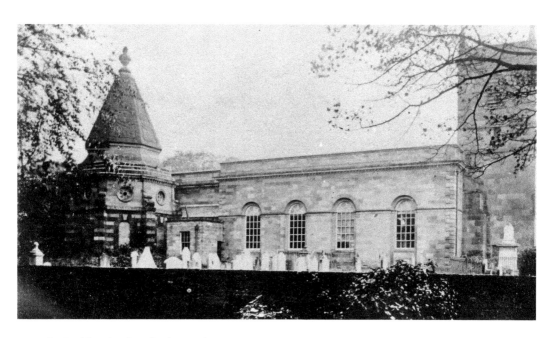

St Cuthbert's Church about 1875

There is evidence that the site was first used by the Vikings as a burial ground in the ninth century. The original church was demolished and rebuilt in 1763 by Robert Corney, a Coatham stonemason who is buried in the churchyard. The fine pillars and gate of the church were restored in 1934 and then again in 1994.

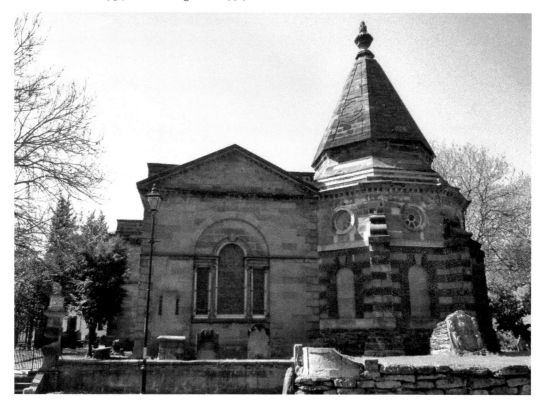

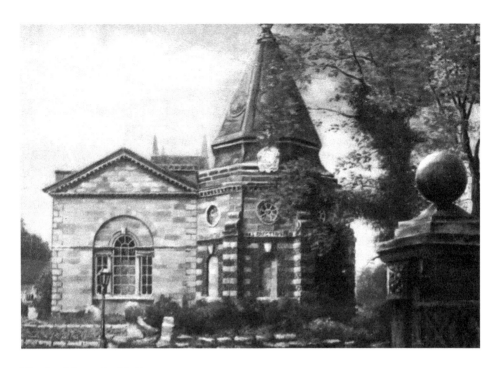

The Banishment of Evil

Built by Cholmley Turner and designed by James Gibbs, the Turner Mausoleum was in memory of his son, Marwood William, who died from cholera or typhus at the aged twenty-one while on his Grand Tour in 1739. His body was brought back from Lyons and laid in the Mausoleum. The striking skull and crossbones represent 'The Banishment of Evil from this Holy Place'.

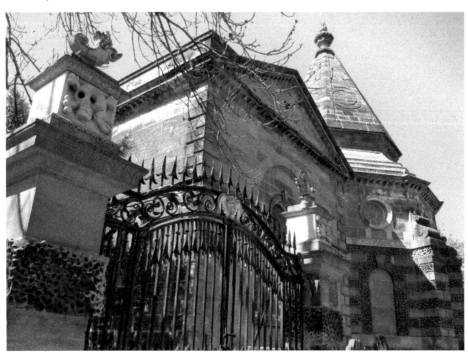

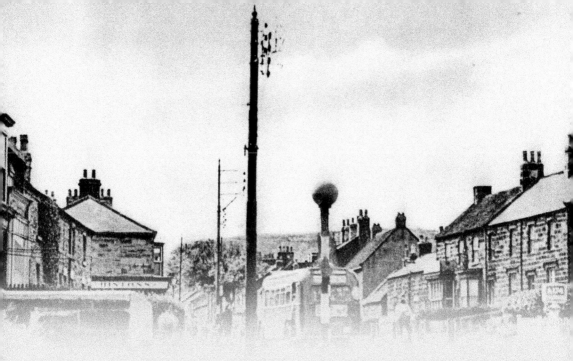

CHAPTER 3

Marske

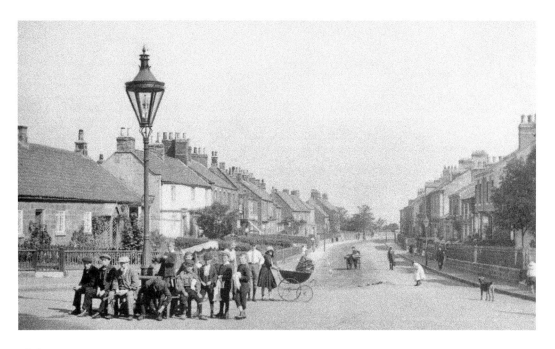

High Street

The abrupt turn taken by the High Street as it leads down to the sea is explained by the fact that there was no way through from the Ship to or from Redcar before the 1925 Coast Road was built. To the right, at what is now 105 High Street, was Marske Farm, formerly the Dundas Arms, the inn where Charles Dickens stayed when he came to look for the grave of Captain Cook's father *en route* to Whitby after his brief visit to Redcar. The gas lamp here replaced a drinking fountain.

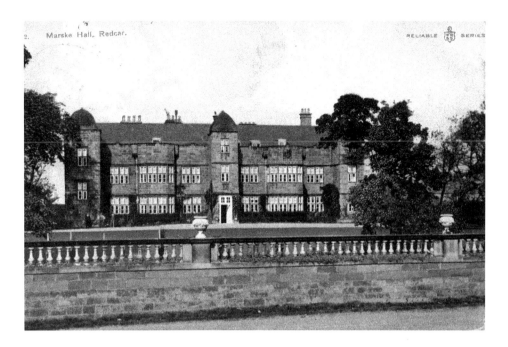

Marske Hall

This is next to St Mark's church on Redcar Road; Marske Hall was built in 1625 by Sir William Pennyman. He had married Ann Atherton, a descendent of Lord Fauconberg, owner of much of the land around Marske from the thirteenth century. The Hall was sold to the Lowther family in 1650 at a knock-down price to enable Pennyman to pay the £1,200 fine he received for his Royalist sympathies. The Quaker William Penn, founder of Pennsylvania, lived there for a while. In 1750 the Dundas family, who later took the name Zetland, bought the Hall. During the First World War, it was requisitioned by the Royal Flying Corps stationed at the nearby aerodrome. The Zetlands moved out in the 1950s when the building became a school and then, in 1961, Lord Zetland gave it to the Leonard Cheshire Foundation for the Sick.

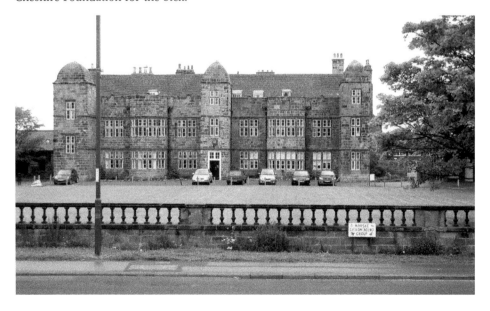

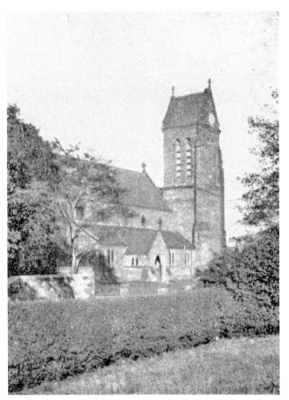

St Mark's Church

This photograph shows the old, pre-fire tower on the church, which dates from 1867. About the same time, it was decided to demolish St Germain's church in Valley Gardens; however, the workmen did not take the 'Hob Men' into account. These were goblins who systematically rebuilt the church each night after the workmen had demolished it by day. To overcome this annoying inconvenience it was decided to blow up the church with gunpowder. The Norman font was rescued and placed in St Mark's along with a Saxon cross that was found in 1901. Captain James Cook's father, James, is buried at St Germain's church.

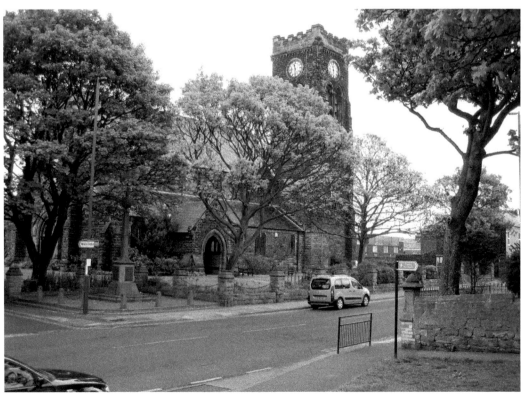

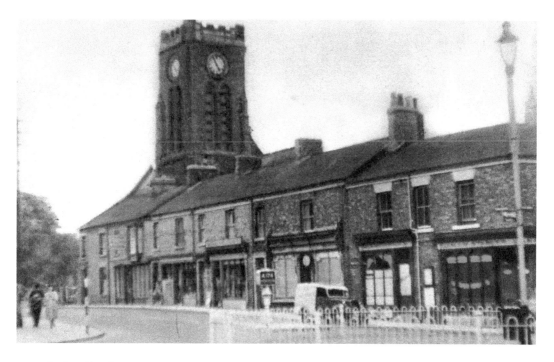

Redcar Road

The wall of the Hall facing on to Redcar Road is not quite what it seems: the pedestals are not made of stone as you would expect – and indeed as they look – but of cast iron. The old photograph shows the top of the tower of St Mark's church and the clock, both of which were replaced after the 1902 fire. The shop on the near right was Aaron Morley's the grocer, with a tobacconist next door, then William's the newsagent, Fitzhugh's the dairyman and Pounder's the gentlemen's outfitters on the end.

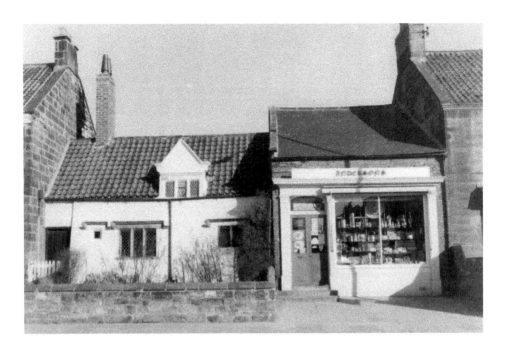

Winkies Castle Folk Museum

Winkies Castle was established by cobbler Jack Anderson in 1975 and bequeathed to Redcar & Cleveland Borough Council on his death in 2001. One of the oldest cottages in Marske, Winkies Castle is the smallest museum in Teesside and is a fine example of a half-cruck cottage dating from the sixteenth century or even earlier. Jack owned the cottage but he never lived there, preferring instead to let it to a one-eyed cat called Winkie; Winkie's home was very much his castle, and his name lives on in the museum's name and logo. The old picture shows the cottage in the 1970s with Jack's cobbler shop next door; the new picture is of the back garden of the museum with its smart outside toilets. The museum has two floors of fascinating displays and exhibits that chart Marske's history down the years – including a stuffed two-headed lamb.

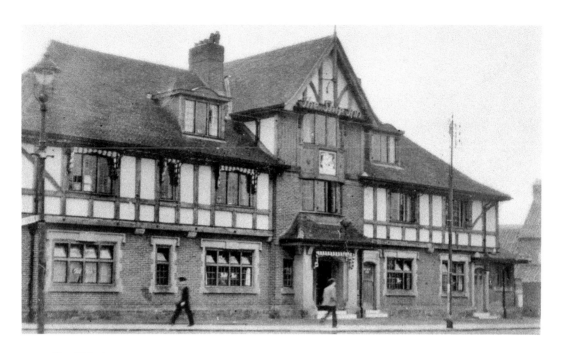

The Ship Inn

The original Ship Inn was on Cliff Terrace; it closed in 1880. This one dates from 1890 and was rebuilt in 1933 in the mock Tudor style you see today. The oak timbers are from the old wooden battleships HMS *Collingwood* and HMS *Southampton*. Originally, half of the building was a public house, the other half a men's club.

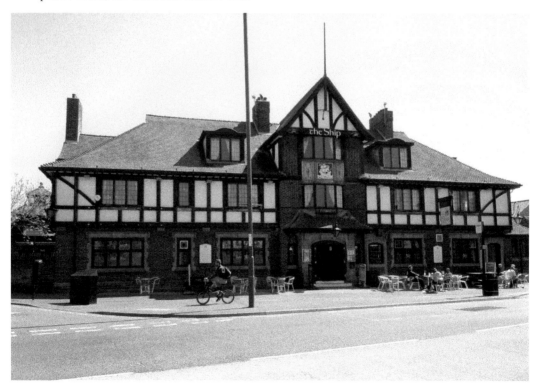

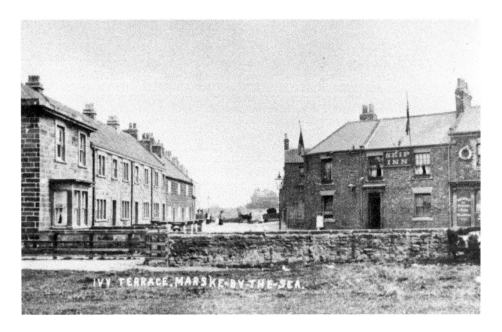

Ivy Terrace

A rare picture of the 1890 Ship Inn with the Police House in Ivy Terrace opposite what is now 163 High Street. Margaret Lowther (see page 61) is famous for the unflattering entry she received in Samuel Pepy's diary: 'Mrs Lowther, who is grown, either through pride or want of manners, a fool, having not a word to say; and as a further mark of a beggarly proud fool, hath a bracelet of diamonds and rubies at her wrist, and a sixpenny necklace about her neck, and not one good rag of clothes upon her back.'

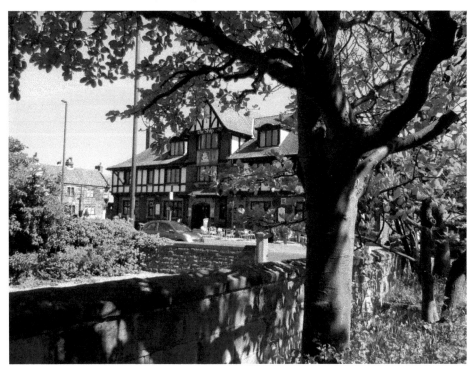

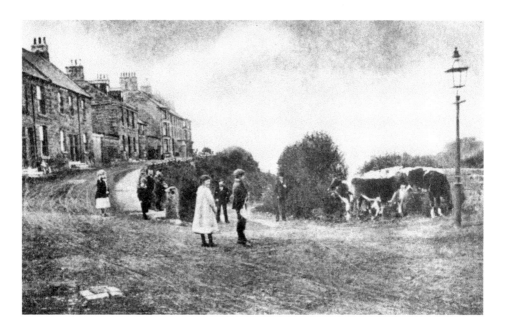

Valley Gardens

The bottom end of Valley Gardens towards Cliff House was rough grazing land, as can be seen here. As part of the High Street, it comprised a number of terraces: Ivy, Shipley, Zetland and Cliff, the last of which survives today. The Gardens took their present shape after Spot Beck – the 'howle' or coastal gulley which formed the valley – was culverted. The contemporary photograph shows the back of Winkies Castle, the wonderfully restored cruck cottage on the High Street; it now houses an equally wonderful museum.

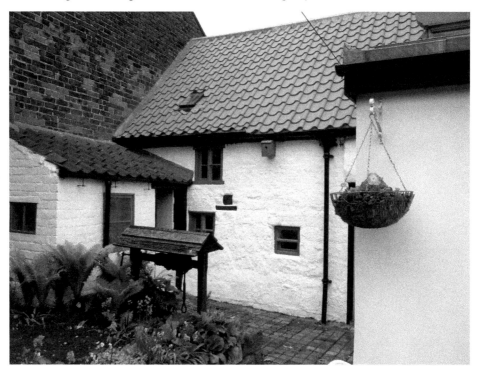

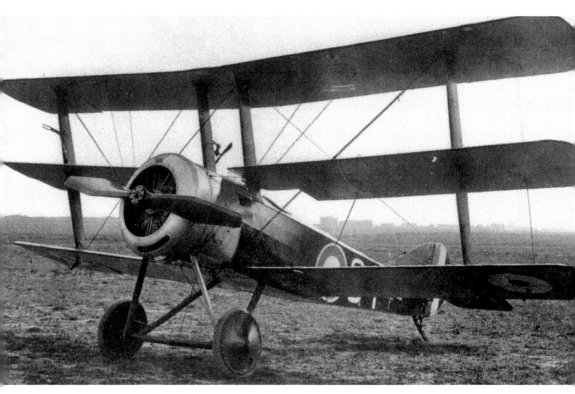

BIGGLES LEARNS *to* FLY

CAPTAIN W.E. JOHNS

Marske Aerodrome, Biggles and Baron von Richthofen

Marske was established briefly as a Royal Flying Corps school in late 1917, closing soon after the end of the First World War; in that short period, though, it became one of the main training centres for aerial combat. Captain W. E. Johns, the author of the *Biggles* books, many of which are still in print today, was a flying instructor at Markse before being posted to 55 Squadron to fly bombers. Flying was particularly hazardous in those days: Johns crashed many times – of the 14,000 pilots killed during the First World War more than half died in training. Captain Roy Brown DSC was also stationed here after he had shot down Manfred von Richthofen, the famous Red Baron who himself had destroyed eighty allied aircraft. After the Second World War, the site of the aerodrome became an ICI depot and later a housing estate. The old photograph shows a Sopwith Triplane at the aerodrome; it is the only Marske aeroplane to have survived and is now on display at the RAF Museum, Hendon. Photograph courtesy of Kirkleatham Museum.

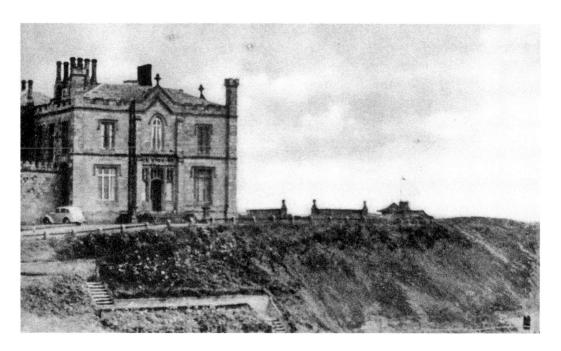

Cliff House

Built by Joseph Pease in 1844 as a summer residence, this moated and castellated Gothic mansion was built with stone from Pease's Upleatham mine. Pease also had interests in the Stockton & Darlington Railway, the mines at New Marske and in Middlesbrough. You can still see the private steps leading from the house to the beach. Legend has it that when the Peases and the Zetlands were both at home (the Zetlands at Marske Hall), locals, particularly children, kept to the Saltburn side of Cliff House so as not to disturb the local grandees.

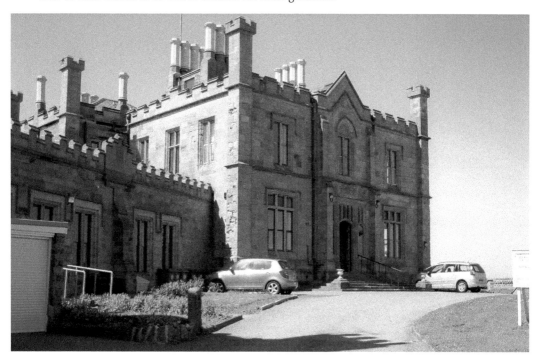

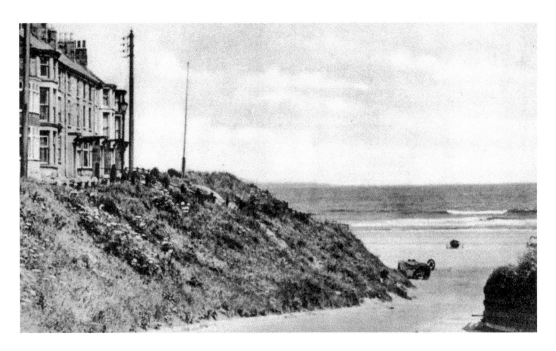

To the Beach

This valley approach to the sea was a perfect route for smugglers. Marske, like other places along this coast, was notorious: even the sexton of St Germain's church in the late 1700s, William Stainton, is said to have stored contraband in his church and in a false grave in the churchyard. He was eventually murdered by the men from the Revenue and secretly buried in his own churchyard, where the ghost Will Watch (Stainton's alias) haunts the place to this day.

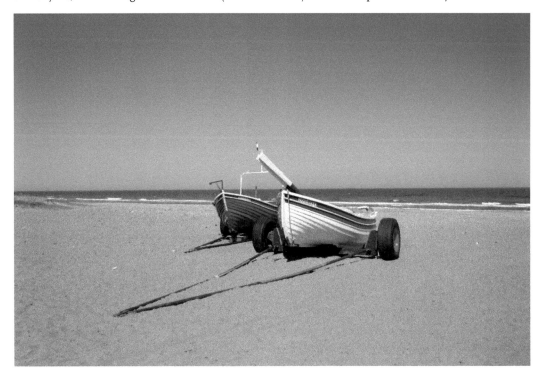

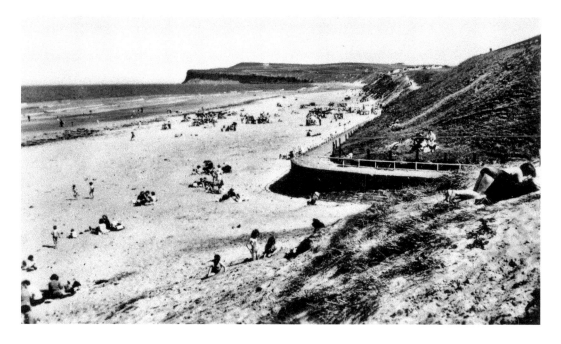

'What is Needed is a Mann of War...'

In a 1799 report Peter Consett for the Revenue describes the local smuggling situation: 'This countrie is fullof villains, who carry on the evil trade ... Coatham is a mean place ... Redcar has several families who make goodly profit from running goods ... this village [Marske] is not so deepe in the trade but nearby Saltburn ... what is needed is a mann of war to cruise the coast ... and stop this iniquitous trade.'

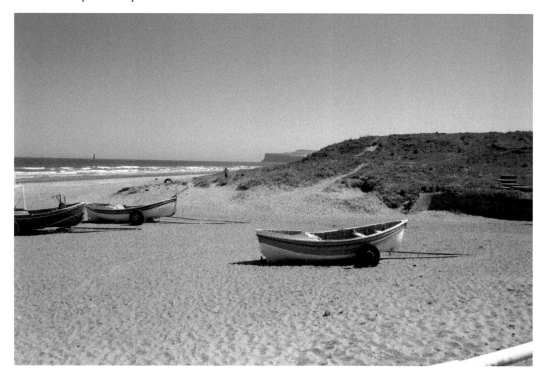

Miners' Hospital, New Marske

New Marske was built by Henry Pease to give his miners a place to live that was closer to the mines in which they worked; he had bought the mines in 1857. He persuaded the local doctor, Dr Streeton, to move out of his house on the corner of High Street and Windy Hill Lane so that it could be converted into the Miners' Hospital, seen here in the older picture. Employees had to pay 6*d* per week, which enabled them to visit the doctor free of charge; house calls and prescriptions were extra. The hospital had two wards of four beds each.

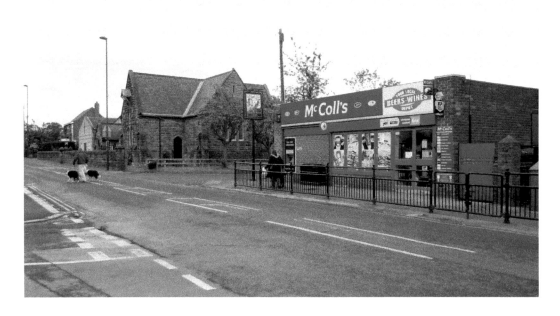

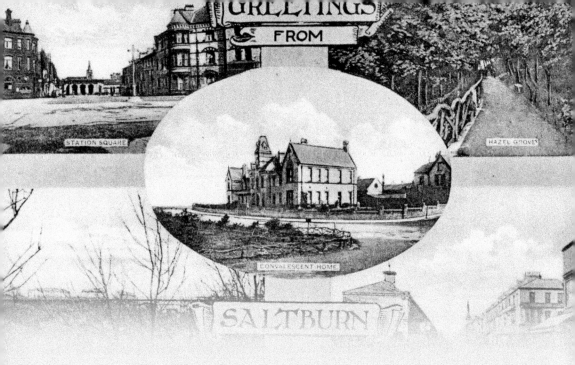

CHAPTER 4

Saltburn

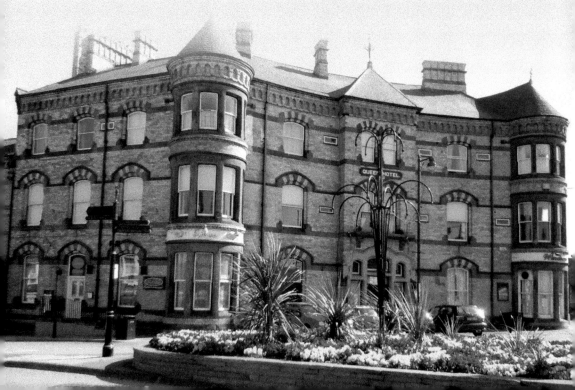

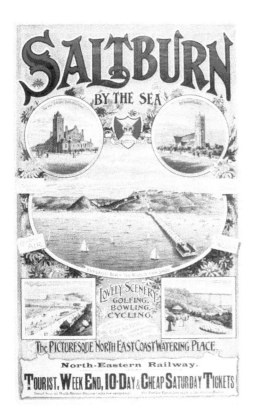

Saltburn

Saltburn grew out of Henry Pease's vision from around 1860 of a 'town arisen on the edge of a cliff'. Before Pease, Saltburn was a mere hamlet of twenty or so houses occupied by fishermen or alum mine workers. Pease set up the Saltburn Improvement Company to achieve his aim and extended the Stockton & Darlington Railway to the town. George Dickenson, architect from Darlington, was engaged to design the streets, ensuring a degree of architectural unity. The older picture is a North Eastern Railway poster from about 1910 promoting the spa qualities of the resort and boasting 'the only brine baths in the north' as well as 'bracing air' and 'a picturesque ... watering place'. The newer picture shows the classic Saltburn view looking towards Huntcliff.

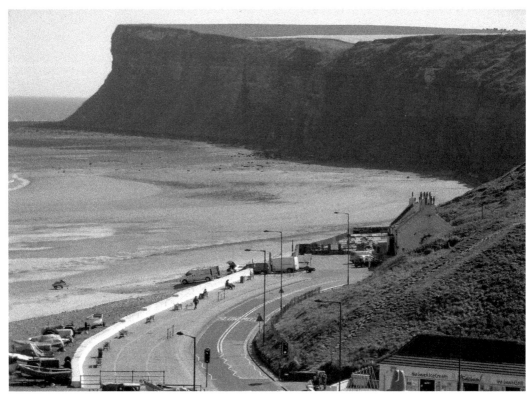

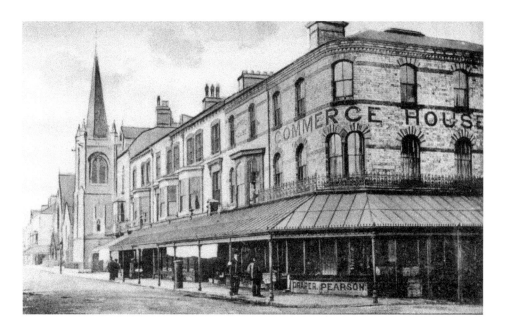

Milton Street

Along with Dundas Street, Milton Street is one of the two main streets in Saltburn. A consequence of Pease's Quakerism was the absence of public houses in new Saltburn, with alcohol available only in the hotel bars or in The Ship in old Saltburn. It was not just alcohol that was restricted: trades such as tanning, soap boiling, tallow melting and candle making, as well as farriers, blacksmiths and tripemen, were all prohibited and anything else that might be deemed a 'public or private nuisance' was banned. Note the fine ironwork on the corner buildings, much of which survives today.

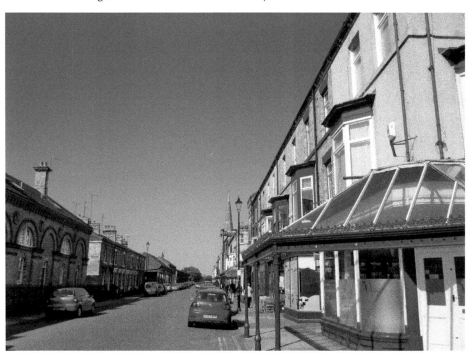

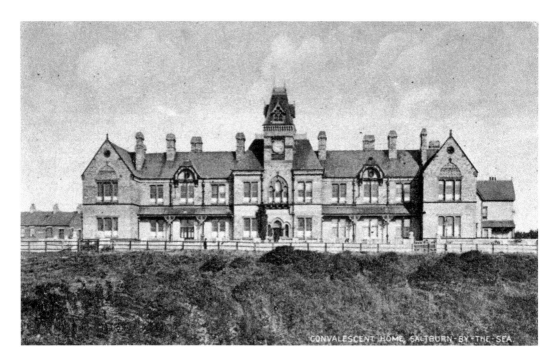

Saltburn Convalescent Home

In line with his Quaker principles, Henry Pease opened this home in 1872 to care for seventy of his workers free of charge for one week. On average, 500 patients were looked after every year. The home replaced an earlier convalescent home that had been housed in two cottages in Garnet Street from 1867, with 168 patients benefitting in 1868.

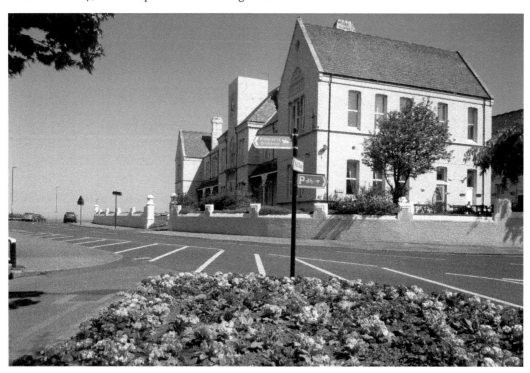

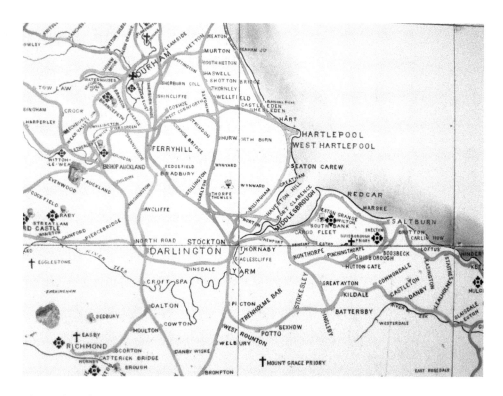

The End of the Line

The extension of the railway to Saltburn under the aegis of Henry Pease was crucial to the development of the town, bringing as it did tourists and visitors, principally day trippers on special excursions, by the thousands. To Pease it was also important to provide railway access to the town so that it might benefit from the burgeoning iron and limestone industries. Saltburn is at the end of the line from Middlesbrough and Darlington; the Redcar to Saltburn Railway, opened in 1861, was an extension of the Middlesbrough to Redcar Railway of 1846. The iconic tile map can be seen outside the railway station shown in the modern photograph.

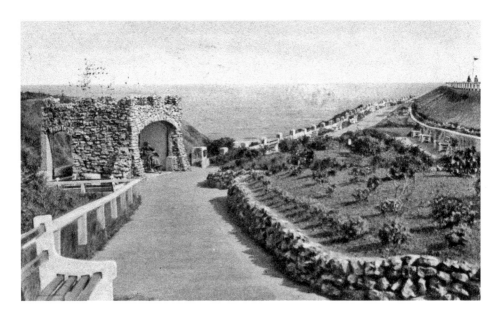

Cliff Gardens, 1934

Henry Pease built 'Teddy's Nook' in 1862 on Marine Parade near to here, a house which deserves a book all of its own. Two eccentric ladies who lived there kept a lion as a pet, exercising it daily on the beach; it is buried somewhere in the garden. Lillie Langtry stayed at the house between 1877 and 1880 and was often visited by Edward, Prince of Wales, who kept a suite of rooms at the Zetland Hotel – hence the name Teddy's Nook. In the Second World War, German spies are alleged to have signalled to ships out at sea by means of flashing lights from Teddy's Nook. The Kelly family, who leased the house in later years, were cousins of Jimmy Savile, a regular visitor. The magnificent bandstand in the new photograph stands at the top of the gardens; it was opened in 1997, designed by Peter Fenton, and hosts free concerts each summer.

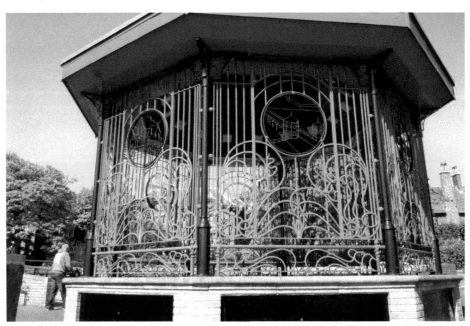

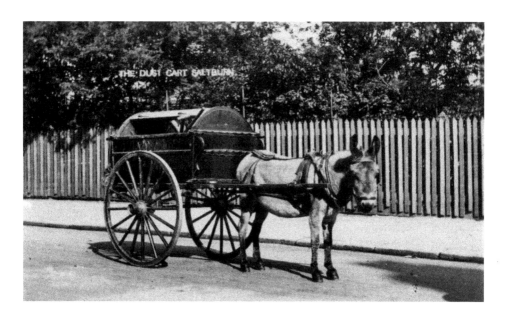

Jerry the Donkey

Jerry the donkey had two vital roles: the first was to spray water on the dusty and sandy streets; his two refilling points were in Milton Street and near Brockley Hall. Jerry also pulled the refuse cart around town, as pictured here. Water of a different kind though was being analysed in Victorian Saltburn in a bid to promote the town's credentials as a spa. Dr Newton Samuelson FCS concluded that the mineral waters from the spring in the Italian Gardens were comparable to some of those found at Harrogate. The new photograph shows yet another form of water that is important to Saltburn – the waves that are now attracting increasing numbers of surfers from all over Europe.

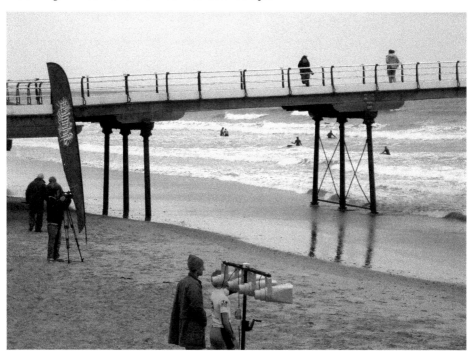

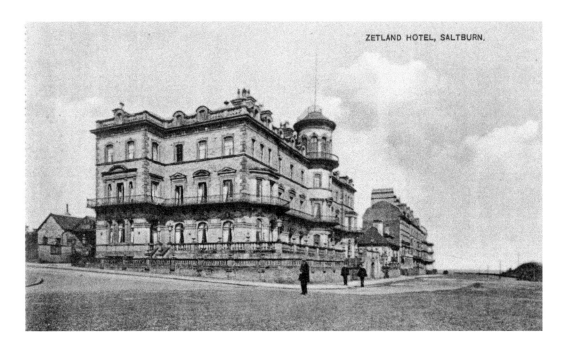

The Zetland Hotel and the Celestial City

The hotel opened in 1863, the jewel in the crown in Henry Pease's bejewelled city with its Emerald, Ruby, Amber, Garnet, Pearl, Coral and Diamond Streets. Saltburn has variously been called the Celestial City, the New Jerusalem, the Brighton and the Tenerife of the North, although anyone who has been to any of these fine places, not least the Celestial City, may note a hint of hyperbole. The central tower of the hotel was a telescope room. Stores for the hotel and first-class passengers came by rail right up to the platform at the back door, making this establishment the first railway hotel in the world. Today the Zetland along with the Queen's (see page 73) and Alexandra hotels have been converted into apartments.

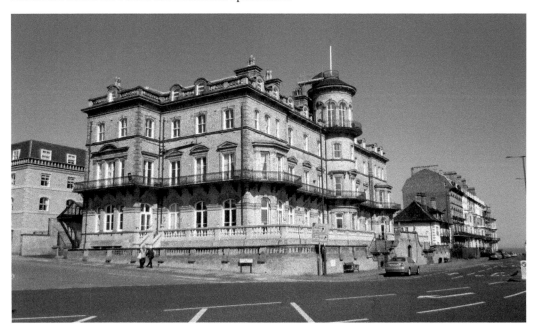

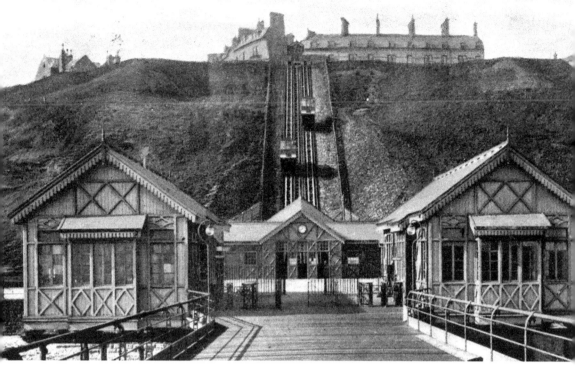

The Cliff Tramway

This is the oldest surviving, working, water-balanced hydraulic tramway in Britain and was built in 1884 to obviate the steep climb from the promenade to the top of the town. The power is derived from pumping water ballast into tanks on the balanced two carriages. The old photograph is from 1913 but nothing much has changed in nearly 100 years – it is still in superb condition as it effortlessly transports passengers up the cliff face, ten at a time, 100,000 or more per season. The oldest cliff tramway ever was the Bom Jesus funicular in Braga, Portugal.

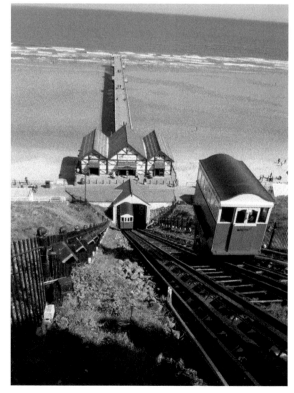

81

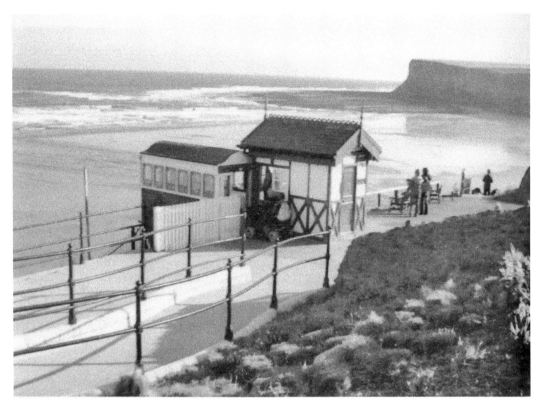

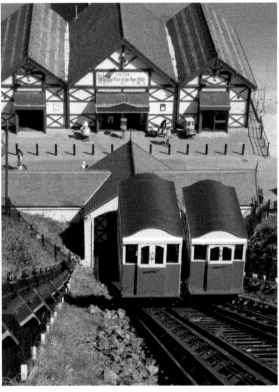

The Vertical Hoist

The lift replaced a vertical hoist that from 1870 hauled a wooden lift up the 120-foot cliff with a cage for twenty passengers, who accessed the cage via a narrow gangplank. A counterbalance tank provided the power when filled with water for ascent, or when emptied of water for descent.

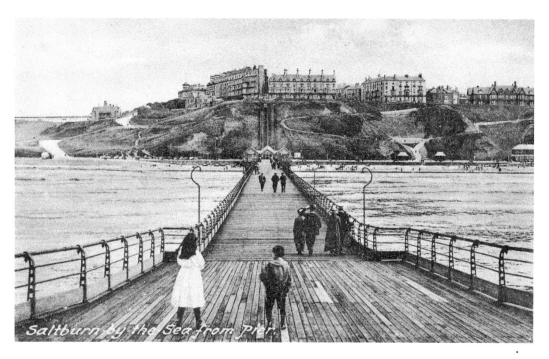

Saltburn by the Sea from Pier

Saltburn from the Pier

The 1,500-foot-long pier was opened in 1869 and featured a number of kiosks halfway along and a landing stage where the steamer from Hartlepool called on its way to Whitby, Scarborough and Bridlington. In the first six months, the pier had 50,000 paying visitors. A storm in 1875 swept away the pier head and landing stage; these were replaced and a bandstand was also added.

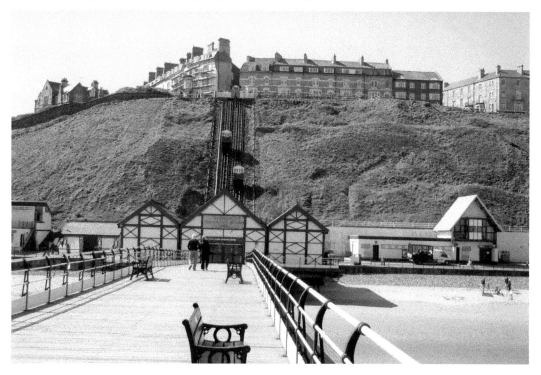

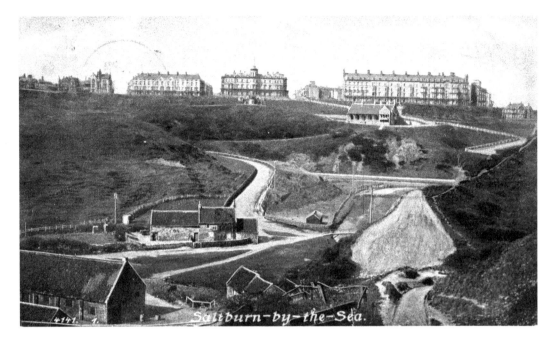

Saltburn Hotels, 1906

The Zetland Hotel was the most popular. Alcohol, though permitted in the bars here, was not allowed on the open terraces; in 1882, John Richardson was fined 5s for drinking a glass of beer outside the hotel. The manager, Mr Verini, was also fined 5s for supplying him. The Zetland Hotel has now been converted into luxury apartments. The Beatles stayed at the Alexandra Hotel in Britannia Terrace before appearing at The Globe in Stockton in November 1963. The Alexandra Hotel & Hydro, as the name suggests, offered a therapeutic heated-seawater swimming bath.

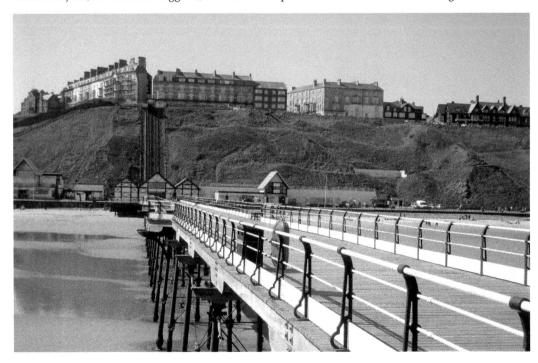

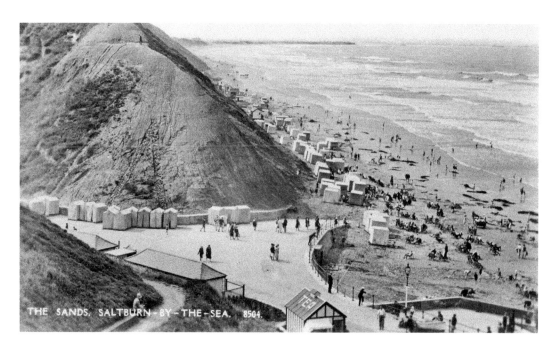

THE SANDS, SALTBURN-BY-THE-SEA. 8504.

Cat Nab

A peculiar clay hill in old Saltburn. There was an Assembly Rooms near here from 1864 which laid on theatre productions, concerts and dances. On August Bank Holiday a children's sand service took place. The Bankside Café and bungalow can be seen in the foreground, now a pub and car park. The name apparently derives from the wildcats that used to roam the shore in search of bird's eggs and fledglings.

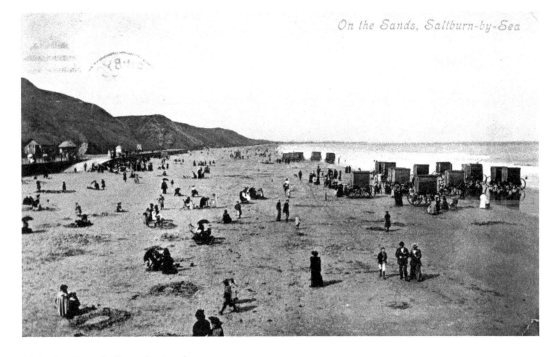

On the Sands, Saltburn-by-Sea

Malcolm Campbell on the Sands

Beach entertainment of a dramatic nature began in the mid-eighteenth century, when Laurence Sterne and the eccentric John Hall-Stevenson raced chariots on the sands. In 1906, the Yorkshire Automobile Club was organising races: a driver named Bianchi achieved 75 mph in a Wolseley and visitors came from all over Britain, indeed the world, as evidenced by the attendance of the Maharajah of Tinkara. The suggestion that Saltburn Bank be used for a hill-climb event was rejected. Malcolm Campbell set his first (unofficial) record of 138.08 mph while driving *Blue Bird* on Saltburn Sands on 17 June 1922. The old photograph is from around 1905.

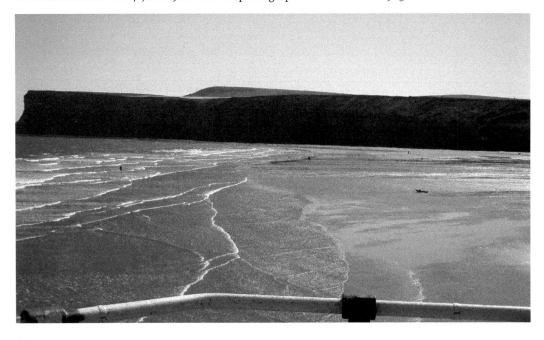

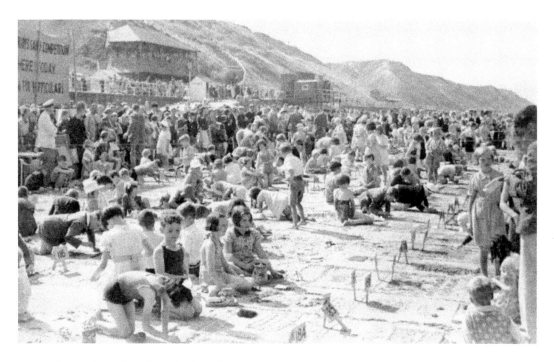

The Sands and Cadbury's Chocolate

One of the popular events on the summer sands was the sand design competitions organised by Cadbury's in the 1930s. Each child was allotted a space on the sand and always went away with a bar of Cadbury's chocolate. As with Redcar, Saltburn offered a wide variety of seaside entertainment, including performing animals, jugglers, firework displays, acrobats and Pierrots. Little Tommy's Nigger Troupe was one of the earliest attractions; Mulvana's Minstrels performed in the 1890s, but it is Grapho and Jackson's Jovial Jollies who were synonymous with Saltburn for forty years.

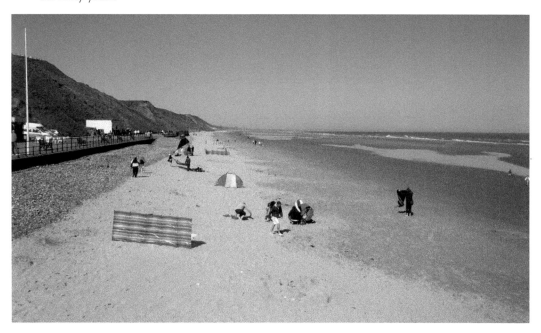

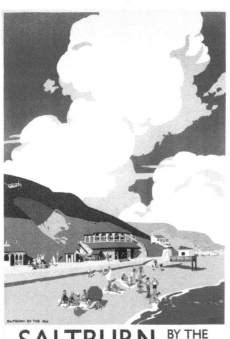

Saltburn Mortuary

Until 1881, the Ship Inn doubled as the local mortuary for victims of drowning: bodies that washed up on the beach were kept there pending post-mortem before a separate mortuary was built. The mortuary was one of three buildings on the site; the nearest to the Ship Inn was the lifeboat house and between that and the mortuary was the Rocket Brigade building. Today only the mortuary remains: the lifeboat house and the Rocket Brigade building were sacrificed to a road-widening scheme. The railway poster by Frank Newbould dates from the 1930s.

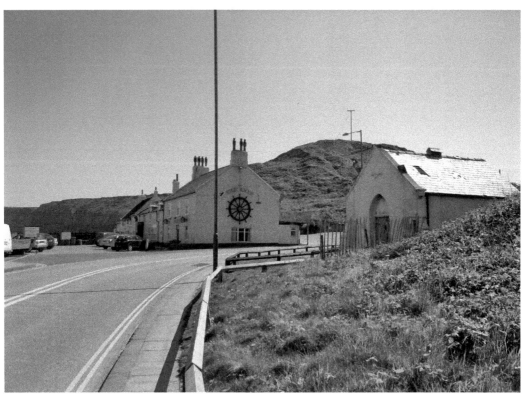

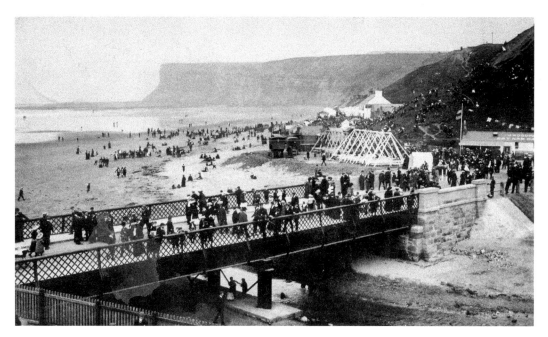

Old Saltburn, 1931

This is virtually all that remains of Old Saltburn, a seaside village whose history extends back many centuries. Originally it consisted of the Ship Inn and the adjacent cottages, the Seagull Inn next to the Ship, another row of cottages on the seaward side of Cat Nab, the Dolphin Inn, the Nimrod Inn, two gin shops, a farm and a shop. The villagers made their living from fishing, sealing, alum manufacture and lime burning. Most lucrative by far though was the illicit trade in contraband, brandy in particular. Cock fighting regularly took place on Cat Nab, and on Sundays geese were brought to market shod in hot tar and sand to facilitate the journey from Brotton.

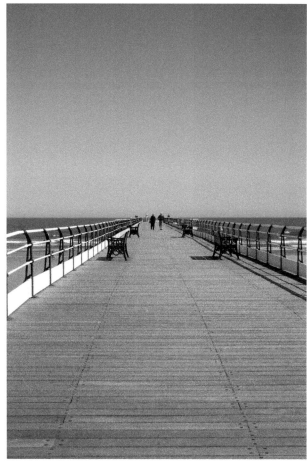

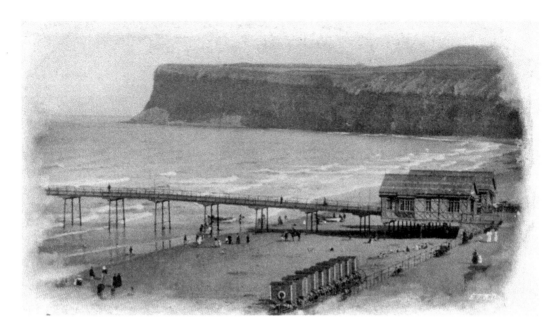

Saltburn Pier

The huge Huntcliff dominates the background. In 1911, the remains of a Roman fort were excavated here: fourteen skeletons found in a well all showed signs of having been brutally killed. Unfortunately, what was left of the site slipped into the sea as a result of coastal erosion. The pier opened in 1869 and was generally regarded as 'a wonder' with 50,000 visitors in the first six months. At 1,400 feet the pier was over a quarter of a mile long when first built; however, the *Ovenbeg* reduced it to 600 yards when she collided with it in 1924. Saltburn's pier was the first iron pier to be built on the north-east coast; it is the most northerly surviving British pier and the only remaining pleasure pier on the north-east coast. It won the coveted Pier of the Year award in 2009.

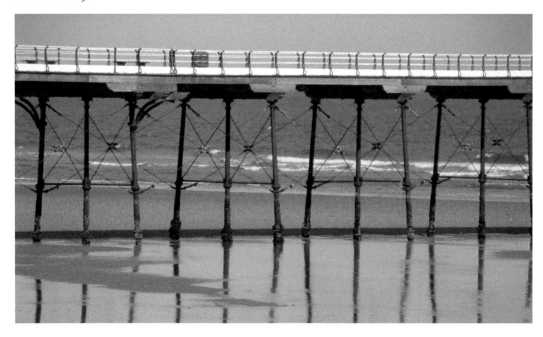

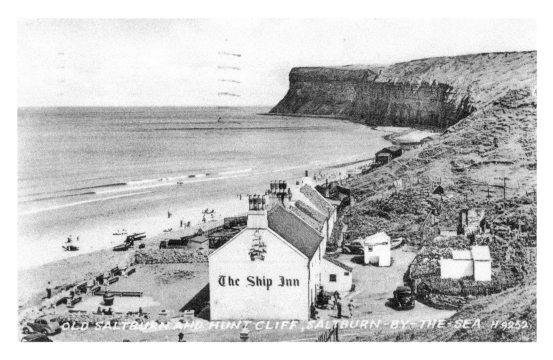

The Ship Inn

As we have seen, at one time the fishing hamlet of Saltburn could boast four inns. The Ship dates back to the late 1500s; it has been extended over the centuries – the original bar is the one closest to the road. Its most infamous landlord was John Andrew in the 1770s; he was known locally as 'Big Jack' or the 'King of Smugglers'. Although electricity came to Saltburn in 1900, hurricane-style lamps were still being used in the Ship Inn up to the end of the Second World War.

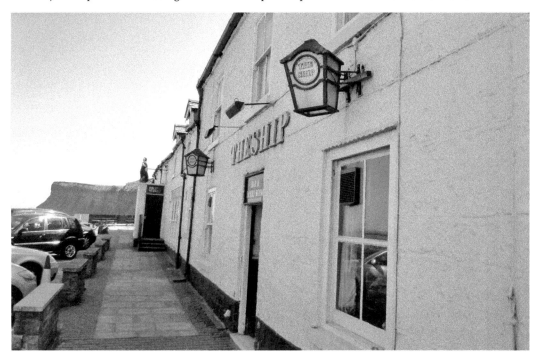

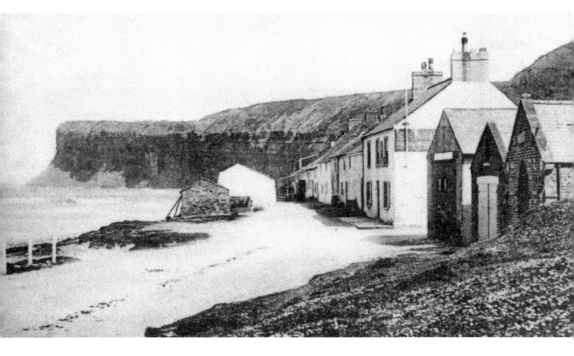

'Andrew's Cow Has Calved'

The phrase 'Andrew's cow has calved' indicated that a boat was ready to be unloaded and packhorses were on hand to take the smuggled goods to safe hiding places. Big Jack was eventually captured in 1827. Saltburn was given its own detachment of coastguards, who lived in a row of specially built cottages on Huntcliff.

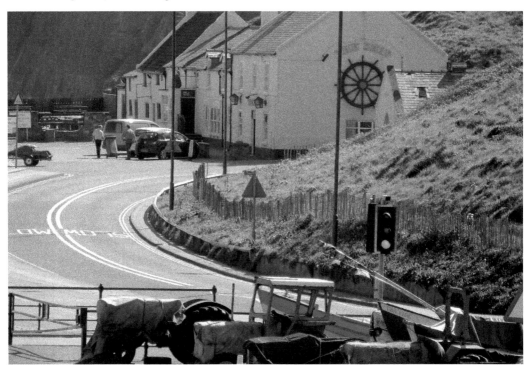

The Towers – 'A High Class
Efficient School at Moderate Fees'
Apart from the usual subjects and
activities, cricket, woodwork and
Greek dancing were all on the
timetable for the girls who boarded
here. This advertisement appeared
in the 1928 York Historic-Pictorial
compiled and published by Harold
and Peter Hood of Middlesbrough.
It shows the four houses ('all
with sea views') that made up the
school – Glenside, The Towers,
St Margaret's & St Hilary's, and
St Katharine's – along with the
Preparatory House and main school
church parades. The school focused
on outdoor activities and boasts
'splendid physical training', Girl
Guides, musical training with choir
and orchestra, and a 'wonderful
health record'.

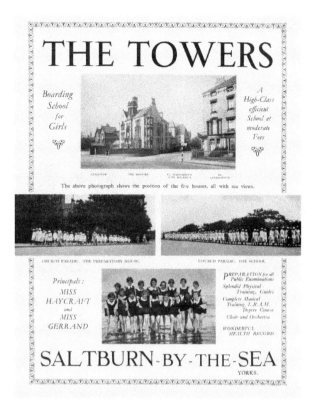

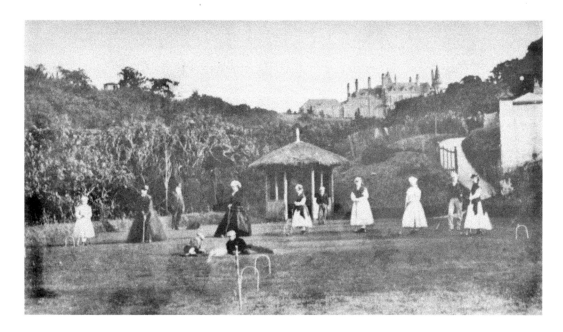

Anyone for Croquet?

The Italian Gardens were to Henry Pease, their creator, 'where Art has converted into a paradise of Beauty'; apart from the terraces, greenhouses and gardener's house, there were lawns for tennis, bowls and croquet. The croquet lawn, laid down in 1864, was superseded by a bowling green in 1903. After the death of Prince Albert, the portico of Barnard Castle station, The Albert Temple with its Corinthian columns, was removed and erected here in 1861 as an Albert Memorial. There was also a chalybeate spring at the foot of Camp Bank, lending the gardens something of a spa atmosphere. Taken about 1890, this fascinating photograph shows Rushpool Hall in the background.

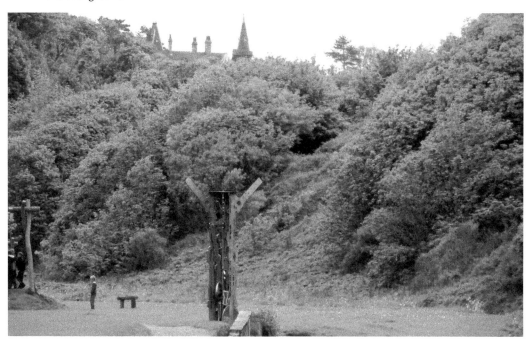

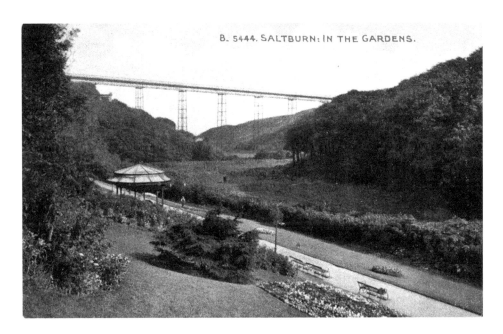

The Italian Gardens

The 1869 iron-girder Ha'penny Bridge was 650 feet long and 120 feet high. Its name comes from the toll payable to cross it. Tragically, three men died during its construction. The idea was to link the new town with Skelton Castle, but the bridge was never used very much and, being unsuitable for motors, never really flourished. In its 105-year history, the bridge was the scene of seventy-nine suicides, all on the seaward side. The only survivor was a young woman whose skirts acted as a parachute. The bridge was demolished in 1974, taking sticks of gelignite four seconds to obliterate this magnificent structure forever. The new photograph shows the miniature train disappearing round the bend in the gardens.

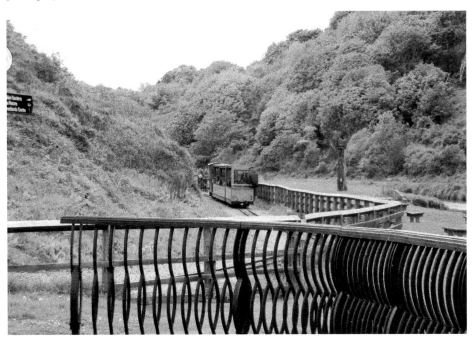

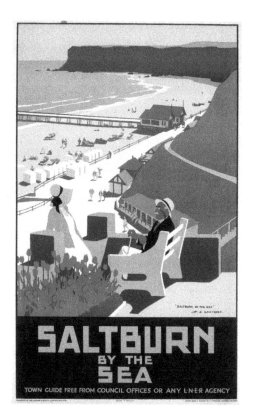

Saltburn: 'A Bit of Civilisation'

Henry Pease's hard work and vision appeared to have paid off if the *Daily Telegraph* of 21 September 1893 is to be believed: 'Saltburn is a bit of civilisation which increases the charms of the country around.' Although by no means a perfect place – there are records from 1877 of a pig being kept in a bathtub in Garnet Street and of eleven people sharing three rooms surrounded by open ashpits – it was nevertheless, and still is, a valiant attempt to provide a decent place for people to live in. The LNER poster is from the 1930s and is by H. G. Gawthorn; the new photograph shows the finely preserved interior of the Cliff Tramway.

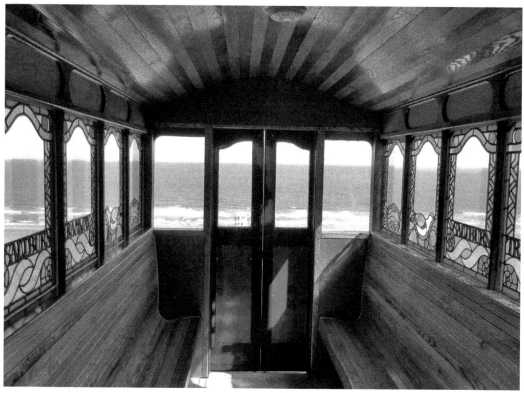